TEXAS

ART OF THE STATE

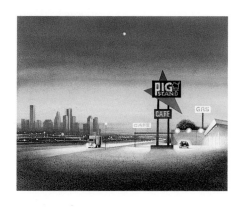

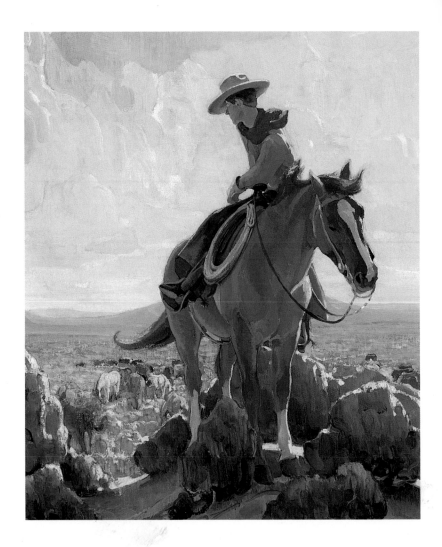

ART OF THE STATE

TEXAS

The Spirit of America

Text by Michael Ennis

Harry N. Abrams, Inc., Publishers

NEW YORK

This book was prepared for publication at
Walking Stick Press, San Francisco

Project staff:
 Series Designer: Linda Herman
 Series Editor: Diana Landau

For Harry N. Abrams, Inc.:
 Series Editor: Ruth A. Peltason

Page 1: *The Evening Star* (detail), cover illustration by Wendell Minor for
 the Larry McMurtry novel of the same name, 1992. *Courtesy the artist*

Page 2: *The Horse Wrangler* by W. Herbert Dunton, 1928.
 San Antonio Art League Museum

Library of Congress Cataloguing-in-Publication Data

Ennis, Michael.
 Texas / text by Michael Ennis.
 p. cm. — (Art of the state)
 ISBN 0–8109–5564–4
 1. Texas Miscellanea. 2. Texas Pictorial works. I. Title.
II. Series.
F386.E66 1999
976.4—dc21 99–27137

Harry N. Abrams, Inc.
100 Fifth Avenue
New York, N.Y. 10011
www.abramsbooks.com

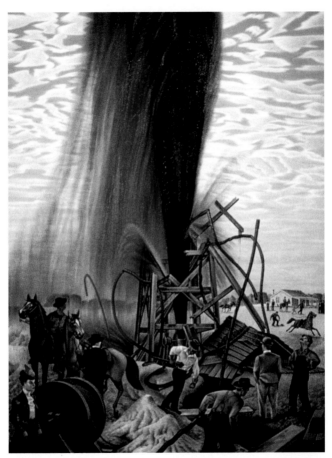

Spindletop Runs Wild by Alexandre Hogue, 1940. Nearly 40 years after the famous gusher launched Texas's first oil boom, its furious energy was captured by regional artist Hogue. *Private collection. Photo Art Museum of Southeast Texas*

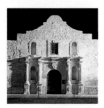

> *"A new-born race, hatched in the United States and called Texan..."*
>
> Nicholas D. P. Maillard, A History of the Republic of Texas. . . , 1842

Few Texans have forgotten that their state was once an independent nation. And by almost any measure the former Republic of Texas remains more nation than state: larger than France, Belgium, the Netherlands, and Switzerland combined, Texas has nearly 20 million citizens—the second most populous of the United States—and a thousand-mile-long border with another nation, Mexico, with which it shares a past and future in a way most outsiders can understand only by looking at, say, the relationship between France and Germany. It is a "nation" that has surrendered autonomy only in the technical sense, and that in many ways still considers itself the "Lone Star" in the American firmament.

"Texas isn't a state, it's a state of mind," the oft-heard saying goes. But Texas is actually a remarkably variegated meeting of the minds, a place of historic collisions: between native Americans and immigrant Americans; between the Old South and the New West; between the Anglo-Protestant culture of North America and the Hispanic–Roman Catholic culture of Latin America; between remarkably persistent small-town values and the glittering, postmodern internationalism of three of the nation's ten largest cities, where even the suburbs have designer high-rises.

The evidence of those collisions is a demographic mosaic, a state more diverse than any save California and New York, and rapidly becoming more so. Already four in every ten Texans are racial or ethnic minorities. But

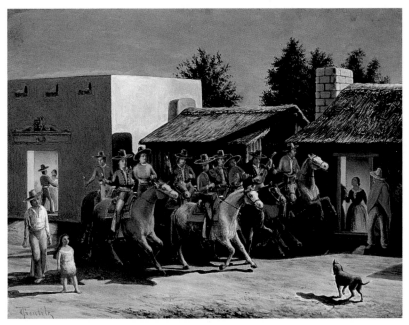

El convite para el baile (Invitation to the ball) by Theodore Gentilz, c. 1890s (after an 1840s work by the same artist). *Yanaguana Society Collection, Daughters of the Republic of Texas Library*

Texas has always been a nation of immigrants, from the Canary Island colonists who settled San Antonio in the 1700s, to the German artists and intellectuals who built central Texas towns like Fredericksburg and New Braunfels in the succeeding century, to the Vietnamese who have recently given coastal metropolises like Houston and Port Arthur another ingredient in a rich medley of African-American, Hispanic, Cajun, and Anglo-southern cultures. Wurstfests and Day of the Dead celebrations attest to the

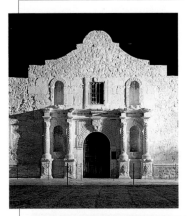

The Alamo, San Antonio. *Photo Gary Cralle/Image Bank*

strength of ethnic roots, but more often than not a cultural mix-and-match gives Texas much of its character. Cowboys on the first trail drives—many of them newly freed slaves—adopted the traditions of Spanish *vaqueros*. Late-19th-century Mexican immigrants inflected German and Czech polkas with their own rhythms and created *conjunto*, a music as uniquely indigenous as Tex-Mex cuisine. The *frontera*—a hundred-mile-wide swath extending along the border with Mexico—is becoming a hybrid civilization unto itself, its chroniclers ranging from the bilingual disk jockeys of Corpus Christi and Brownsville to novelists Cormac McCarthy and Rolando Hinojosa.

To cross this nation-state's thousand-mile breadth (and it's another thousand miles from top to bottom) is to journey, ecologically speaking, from one end of the continent to the other—from the wild orchids blooming in the southern gothic swamps of East Texas's Big Thicket, to the bluebonnet-blanketed Hill Country, to the cactus-spiked desert flats and pine-fragrant mountains of the Big Bend. But to say that this is a land of mere contrasts is to miss something more vital; Texas is a land of profound paradoxes. It is a land crossed by a dozen major rivers, with more miles of coastline than any state except California and Florida—yet Texans have always sought their collective identity on arid, inhospitable high plains still so thinly populated that they meet the official definition of a frontier. The

land has produced wealth measured in internationally acclaimed cultural monuments like Louis Kahn's Kimbel Museum and Renzo Piano's Menil Collection, yet a culture of poverty shaped by slavery and sharecropping has produced some of Texas's greatest art: the East Texas country blues of "Blind" Lemon Jefferson and Huddie "Leadbelly" Ledbetter, the dust-bowl landscapes of Alexandre Hogue and the "Dallas Nine," and folk expressions ranging from the naive paintings of former sharecropper Ezekiel Gibbs to the sculpted concrete *capillas*—yard shrines—found in San Antonio's barrios.

The greatest of all Texas paradoxes, however, is that a state that should be several states—Texas was offered the option to split into five states when it came into the Union—is inhabited by a polyglot populace that overwhelmingly considers itself simply "Texan." This much-discussed Texas nationalism is more than a clever catchphrase. It is rooted in Texas's own revolutionary war, which gave the state a pantheon of founding heroes—a list later expanded to include such archetypes as the Texas Ranger, the Cattle Baron, and the Wildcatter. Although flawed with racism and historical inaccuracies, the Texas Myth still celebrates a universal Texan faith: a belief in the "go-ahead" spirit that conquered an unforgiving land, that transformed wandering rogues like Travis and Crockett into heroes, that has always offered anyone, regardless of status or origin, the power to leave the past behind and embrace a hope and a dream called Texas. ❧

Face jug by Carl Block, 1998.
Webb Gallery, Waxahachie

"Friendship"

State motto, adopted in 1930 to recognize
the derivation of Texas from tejas, the
Caddo Indian word for "friend"

**Mockingbird and
bluebonnet**

TEXAS

"Lone Star State"
28th state

Date of Statehood
DECEMBER 29, 1845

Capital
AUSTIN

Bird
MOCKINGBIRD

Flower
BLUEBONNET

Tree
PECAN

Large mammal
LONGHORN

Small mammal
ARMADILLO

Reptile
TEXAS HORNED LIZARD

Statehood didn't deter Texans from preserving the symbols of their independence. The famous Lone Star flag adopted by the infant Republic of Texas in 1839 became the state flag without the slightest change, and the Great Seal of the Republic made a similar transition. The proud, solitary star at its center is such a ubiquitous symbol that it's hard to think of something Texan it hasn't adorned: saddles, manholes, beer cans, well pumps, and uncounted small-town diners where it instantly signals "Texan spoken here."

The Texas state legislature, despite convening only every other year, has found time

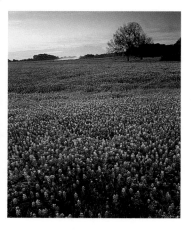

to endorse more than two dozen symbols. Legislators have historically favored hardiness rather than charm: the ornery but indefatigable longhorn; the uncuddly armadillo; the self-reliant prickly pear cactus. Likewise, sideoats grama, the state grass, thrives from the blackland prairie of humid East Texas to the dry rocky soils of the west; sprouting perennially despite drought and freeze, it remains the forage of choice for free-ranging Texas beef. ◗

Of Flowering Fame

The bluebonnet had been the state flower for 13 years when Julian Onderdonk painted *Bluebonnet Scene* in 1914. Onderdonk's impressionistic treatment was surprisingly sublime, but the indigenous genre he founded was quickly commercialized to the point that "bluebonnet painter" has long been a scathing critical pejorative. The bluebonnets themselves haven't suffered from the association; their April flowering, painted directly on the central Texas landscape, continues to inspire rapture.

Right: "Armadillo Jim," New Braunfels. *Photo Will van Overbeek. Above:* Bluebonnets near Waco. *Photo Michael Hardeman. Opposite:* Watch case with repoussé longhorn by Samuel Bell of San Antonio, 1960. *Courtesy Walter Nold Mathis, San Antonio Photo the Witte Museum*

Pecan Pie

Real Texans do eat chili, but many a fine down-home eatery can get away with not serving it. The same can't be said with regard to "pee-can" pie.

½ cup sugar
1 cup dark sorghum molasses
3 tbsp. butter
3 eggs
1 tbsp. vanilla flavoring
Pinch of salt
1 cup fresh pecan halves
1 tbsp. flour
1 tbsp. sugar
1 unbaked pie crust

Stir sugar and molasses over a moderate flame until they boil. Stir in butter. Meanwhile beat eggs until blended. Pour hot mixture over eggs and stir. Add flavoring, salt, and pecans. Now mix the flour and 1 tablespoon of sugar. Sprinkle this over the bottom of the unbaked crust, add pecan mixture, and cook in a moderate (350° F) oven about 45 minutes.

Adapted from Jane Long's Brazoria Inn: An Early Texas Cookbook

"Texas, Our Texas"

Texas, our Texas! All hail the mighty State!
Texas, our Texas! So wonderful, so great!
Boldest and grandest, Withstanding ev'ry test;
Thro'out the ages long.

God Bless you, Texas!
And keep you brave and strong,
That you may grow in power and worth,
Thro'out the ages long.

Texas, O Texas! Your freeborn Single Star,
Sends out its radiance to nations near and far.
Emblem of freedom! It sets our hearts aglow,
With thoughts of San Jacinto And glorious Alamo.

Music by William J. Marsh, lyrics by Marsh and Gladys Yoakum Wright. Their song won a contest sponsored by the legislature in 1929. When Alaska became a state in 1959, a slight modification was required: "Largest and grandest" in the third line became "Boldest and grandest."

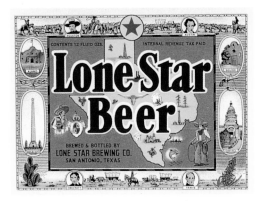

Above left: **Pecan grove in Hill County.** *Photo David Muench/ Corbis.* **Above: Crafted by famed bootmaker Cosimo Lucchese of San Antonio in the 1940s, these boots depict the state capitol and other Texas symbols.** *Lucchese, Inc. Photo David A. Northcott/Corbis* **Opposite: Vintage Lone Star Beer label.** *Private collection*

"Old R.I.P."

The official state reptile, *Phrynosoma cornutum*, is a lizard so ugly they call it a toad. The Texas "horny toad" is a threatened species, but don't say it's not a survivor. "Old R.I.P.," a horny toad sealed in the cornerstone of an 1897 courthouse in Eastland, Texas, was discovered alive and kicking when the cornerstone was opened in 1928. An instant zoological celebrity, R.I.P. toured the nation and was introduced to President Coolidge. Herpetologists call it a hoax— the life span of even a well-fed (ants preferred) horny toad averages six years. But the experts do concede that imperiled horny toads really can squirt blood out of their eyes.

A.D. 800 Caddo Indians begin to develop a peaceful mound-building culture in the Neches River Valley.

1528 Álvar Núñez Cabeza de Vaca and his crew are shipwrecked on the Texas coast.

1540 Francisco Vásquez de Coronado crosses the Panhandle high plains.

1682 Corpus Christi de la Ysleta Mission is established at present-day El Paso; first European settlement in Texas.

1718 Spanish found Mission San Antonio de Valero, later called the Alamo.

1803 Louisiana Purchase puts Texas on the U.S. border. Census finds 100,000 head of cattle, 4,155 humans.

1822 Stephen F. Austin successfully petitions the new government of Mexico to establish a colony.

1829 Mexican government ends slavery; Texans protest and are excluded from the ban.

1830 Mexico prohibits further U.S. immigration; Anglo population, perhaps 15,000, is already three times that of Mexican-Texans.

1836 Alamo falls in March; six weeks later Texas army under Sam Houston defeats Santa Anna at San Jacinto. Houston is elected first president of the Republic of Texas.

1845 Texas enters Union as the 28th state but retains its public lands.

1846 German settlers found Fredericksburg in west central Texas, beginning settlement of the interior.

1851 German painter Hermann Lungkwitz arrives at port of Galveston.

1861 Texas secedes from the Union; almost a third of some 600,000 residents are slaves. Cattle population approaches 4 million.

1867 Chisholm Trail opens between south Texas and Abilene, Kansas.

1871 The state's first opera house opens in Galveston.

1880 Mimbres Apache chief Victorio is slain in Mexico, ending last significant Indian threat to settlement of West Texas.

1882 Westbound and eastbound rail lines meet at Sierra Blanca.

1884 Eight years after introduction of barbed wire to the open range, fence-cutting becomes a felony, ending the era of the great cattle drives.

1890 Reformer James S. Hogg elected governor on an antirailroad, profarmer platform.

1893 Frank Reaugh exhibits his longhorn paintings at Chicago Columbian Exposition.

1900 Hurricane swamps Galveston with a

15-foot storm surge; 6,000 die in worst natural disaster in U.S. history.

1901 Within nine days, the Spindletop gusher exceeds previous year's oil production for the entire state.

1907 Neiman-Marcus department store opens in Dallas.

1914 Julian Onderdonk paints *Bluebonnet Scene*, establishing a genre endemic to the state.

1925 Deepwater portion of 55-mile-long Houston Ship Channel is finally completed.

1925 Blues pioneer Blind Lemon Jefferson makes his first recording for Paramount.

1930 C. M. "Dad" Joiner discovers the East Texas Oil Field.

1934 After eluding lawmen for 21 months, Clyde Barrow and Bonnie Parker are ambushed in Louisiana.

1936 Alexandre Hogue exhibits his classic dust-bowl landscape *Drought-Stricken Area* at the Texas Centennial Exposition.

1947 Houston's Tony Award–winning (1996) Alley Theater is founded.

1948 Lyndon Baines Johnson wins Democratic senatorial nomination.

1949 Painter John Biggers arrives at the new Texas State University for Negroes; founds its art department.

1950 Census shows that for the first time more Texans live in cities than in the countryside.

1959 The Dallas Theater Center opens its Frank Lloyd Wright–designed Kalita Humphreys Theater.

1963 John F. Kennedy assassinated in Dallas; Johnson sworn in as 36th president.

1965 Opening of the Houston Astrodome, world's first domed stadium.

1975 Philip Johnson's Pennzoil Place is completed in Houston, launching the postmodern revolution in high-rise architecture.

1981 Price of West Texas crude oil reaches $34 a barrel, up from $4 a barrel in 1973; immigrants from rust-belt states pour into Texas.

1984 The Museum of Fine Arts, Houston, stages the exhibition *Fresh Paint: The Houston School*.

1986 Falling oil prices plunge the state into economic crisis.

1987 Houston Grand Opera premieres John Adams's *Nixon in China*.

1992 Reform Party presidential candidate Ross Perot, richest man in Texas, wins almost 20 percent of the popular vote.

1994 Population reaches 18.4 million; Texas surpasses New York as the nation's second most populous state.

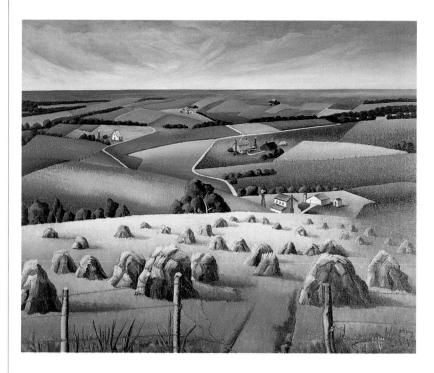

Squaw Creek Valley by Florence E. McClung, 1937. Dallasite McClung often painted the fertile farmland of East Texas, here untouched by the 1930s droughts. *Dallas Museum of Art*

South and West

Texarkana in East Texas is almost 200 miles closer to Atlanta than it is to El Paso; Stratford in the Panhandle is as distant from Brownsville on the Mexican border as Manhattan is from Daytona Beach. Yet a single line of demarcation can partition this vast territory. The 98th meridian—which roughly coincides with a 300-mile rock terrace known as the Balcones

Escarpment (to the Spanish its limestone tiers, up to 1,000 feet high, resembled a balcony)—is the natural divide between the woodlands and rich blackland prairie of the coastal plains and the arid, treeless high plains of the West. For centuries pioneers stared up at the escarpment and knew they couldn't survive in the dry country beyond. But in the mid-19th century, cattlemen began their conquest of West Texas—an achievement, claimed historian Walter Prescott Webb, that forged a new civilization entirely distinct from that of the eastern U.S. Webb's 98th meridian accurately drew the fundamental cleavage in Texas history and society: between the cotton-raising, antebellum culture of the coastal lowlands, and the cattle-raising, Wild West culture of the high plains. In short, Texas can be divided into two parts: south and west.

"WHEN THE EASTERNER CAME INTO CONTACT WITH THIS MAN of the West, whose vision had been enlarged by the distant and monotonous horizon…the Easterner was at once impressed that he had found something new in human beings. The garb, the taciturnity, the sententious speech redolent of the land…."

Walter Prescott Webb, The Great Plains, *1931*

Indian Paint Brush by Mary Motz Wills, c. 1913–36. In 1875, Mary Motz's parents emigrated from Virginia to Waco, where the artist grew up; she later resided in Abilene. Her fame rests on her delicate watercolors of Texas wildflowers, most reproduced in the 1961 volume *Roadside Flowers of Texas. The Witte Museum, San Antonio Left: Red Texan Wolf* by John James Audubon, 1845. *Stark Museum of Art, Orange*

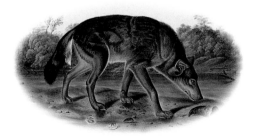

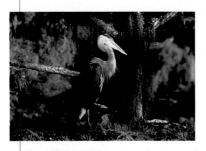

Where the South Ends

Running along the Louisiana border in a swath roughly 100 miles wide, the Piney Woods mark the end of the great southern forest's long procession from the Atlantic. Caddo Indians originally settled in small clearings among the 150-foot longleaf yellow pines; the Spanish, arriving early in the 1700s, grazed cattle on brick-red prairies around Nacogdoches. By the 1830s southerners were chalking "G.T.T." (Gone to Texas) on their cabins and streaming into the area, bringing their slaves, hogs, and cotton culture.

Caddo Lake, ringed by huge cypresses and deepened by an immense natural logjam on the Red River, allowed steamboat navigation all the way from New Orleans, making the town of Jefferson Texas's second-largest port until Army engineers dynamited the logjam in 1873. The Piney Woods logging boom began in the 1880s, quickly depleting the virgin growth; 20th-century reforestation has actually extended the timber-

Great blue heron at Caddo Lake State Park. *Photo Richard Reynolds Below: Edge of the Piney Woods by Julie Bozzi, 1987–88. Dense longleaf pine forests and thickets made the Piney Woods a haven for early-19th-century fugitives and Confederate draft dodgers. Modern Art Museum of Fort Worth*

land into old pastures and plantations. The only primordial wilderness left in the region is the Big Thicket National Preserve—an almost impenetrable, astonishingly complex ecological mosaic and a monument to biodiversity. The shotgun-toting old-timers who still hunt feral hogs in the Big Thicket river bottoms preserve southern traditions—and dialect—little changed since before the Civil War.

"IT'S A BOTANICAL PARADISE. WE HAVE every kind of flower growing in Hardin county that you've got anywhere in the world, I reckon."

A. L. "Leak" Bevil, quoted in Big Thicket Legacy, *1977*

Above: Caddo Lake by David Bates, 1987. Caddo Lake, an ecological preserve since 1993, is the focus of environmentalists' attempts to halt dredging for deepwater channels meant to link East Texas with the Red River. Berggruen Gallery, San Francisco

Heart of Texas

The wide-angle perspectives that dominate the Texas landscape narrow to a more intimate scale in the central Texas hill country. Here, crystal-clear artesian springs and frothing, cypress-lined rivers have etched the limestone shelf above the Balcones Escarpment into a tracery of knobby, juniper-and-oak-sprinkled hills and small valleys. In the mid-19th century, immigrants arduously cleared rocks, built fences and mills, and founded small towns whose ethnic festivals and limestone buildings bespeak their European roots. The countryside offers picturesque anomalies like the fern-draped grottos of Hamilton Pool, created when the roof of a subterranean river collapsed, or Enchanted Rock, a granite dome known to creak at night and glitter eerily beneath a full moon.

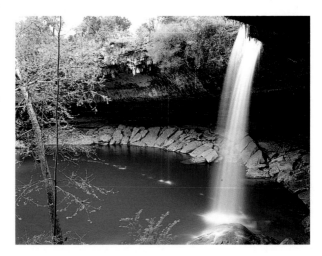

"I SHOULD BE DRIVEN TO EXTREMITIES IN ATTEMPTING TO SPREAD before you the singularly picturesque appearance of the upper country. It had the clear running streams of New England, skirted with heavy timber, high hills of smooth greensward, soil, rich and deep to the very top, here called rolling prairie, occasionally dotted with 'mottes' of timber, resembling old orchards in an old cultivated country—except in the absence of buildings, fences, and improvements."

Rutherford B. Hayes (later the 19th U.S. president), letter dated March 10, 1849

S.W.I.S. Rim, Big Bend #1 by Earl Staley, 1987–91. Staley, the most influential Texas postmodernist, started camping and painting in the Big Bend in the late 1960s and has frequently set his mythic allegories in its rugged, otherworldly landscape. He makes watercolor vignettes in a sketchbook during his Big Bend journeys to guide his painting back in his Houston studio. *Moody Gallery, Houston*

The West is still wild beyond the Pecos River, where counties the size of New England states boast four-figure populations. Big Bend National Park is the chief attraction of the Trans-Pecos; shunned by Spanish explorers as *despoblado* (no-man's land), the spectacular landscape was created as the Rio Grande River carved through volcanic mountains, leaving behind narrow canyons racing with whitewater rapids. The park's temperate Chisos Mountain highlands are forested with Mexican piñon, ponderosa pines, cypress, and indigenous Chisos oaks; on the scorching Chihuahuan desert flats below, roadrunners and horned lizards scurry among ocotillo, lechuguilla, cane cholla, and other spiky succulents. ◗

Cactus Flowers by José Arpa, 1928. Born in Spain, Arpa moved to Mexico City in the 1890s and thence to San Antonio, where he was active as a painter and teacher. His masterly depictions of Texas landscapes "capture the essence of hot sunlight and torpid tranquility," wrote curator Cecilia Steinfeldt. *San Antonio Art League Museum Below:* Lizard, Paloduro Canyon. *Photo Will van Overbeek*

Painters West of the Pecos

The Big Bend has held a particular fascination for 20th-century Texas artists. Celebrated longhorn painter Frank Reaugh began his annual sketching trips to West Texas and the Big Bend in 1917, bringing with him a new generation of Texas artists who went on to establish a nationally prominent regional school in the 1930s. Alexandre Hogue, Reveau Bassett, Olin Travis, and Edward G. Eisenlohr rode along in Reaugh's Model T Ford; Everett Spruce, Otis Dozier, and Jerry Bywaters were other members of the so-called "Dallas Nine" who made their own Big Bend pilgrimages in the thirties.

The First Texans

Arguably the most civilized Texans ever, the Caddo Indians began building ceremonial mounds and large, domelike thatched houses near the Neches River around A.D. 800. Skilled agriculturalists—they produced a maize surplus—and artisans, the Caddo traded with tribes as far away as the Great Lakes. Evidently they traced their descent through the maternal line and worshiped a single supreme deity, the *Caddi Ayo*. The Caddo built no fortifications, suggesting to archaeologists that they enjoyed five centuries of uninterrupted peace before mysteriously sealing over their mounds and abandoning the Neches site. A later Caddo group, the Hasinai, gave Texas its name; *taysha*, their word for "friend" or "ally," was transliterated as *tejas* by Spanish missionaries.

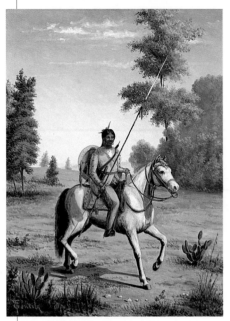

Comanche Chief by Theodore Gentilz, c. 1890s. Gentilz portrays this chief in typical deerskin garb; legend has it he persuaded his subject to pose with the gifts of a sketch and some tobacco. *The Witte Museum, San Antonio Opposite above:*

Comanche village, women dressing robes and drying meat by George Catlin, 1834. *National Museum of American Art, Washington, D.C./Art Resource, New York. Opposite below: White Eagle's Shield* (Comanche), c. 1870. *Panhandle-Plains Historical Museum*

"NEVER RIDE ON A [COMANCHE] BOWMAN'S left; if you do, ten to one that he will pop an arrow through you."

Memoirs of John S. Ford, From 1836 to 1886

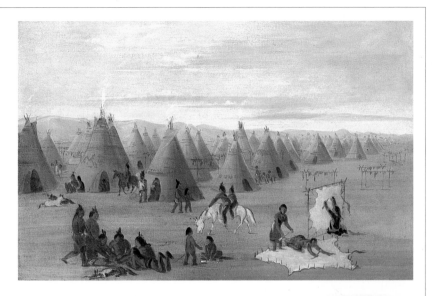

Comanche Empire

The Comanche were just a struggling band of hunter-gatherers before they acquired a Spanish import: the horse. Soon second to none at equestrian warfare, they swept out of New Mexico and ruled the Texas plains for more than a century, a force more inimical to West Texas settlement than even the parched landscape. Indian fighters like Texas Rangers Jack Hays, Bigfoot Wallace, and Rip Ford became subjects of lore and legend, but no tactics could defeat the Comanches on their chosen field. Their empire came to an end in the mid-1870s, when the U.S. cavalry hit on the strategy of seeking out and destroying the warriors' winter food caches.

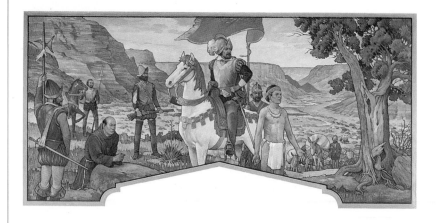

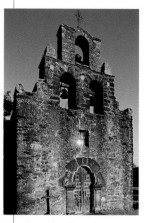

Regarding Texas as a buffer zone for their New World empires, the Spanish and French sparred for more than a century to establish their claims—a competition marked by epic misadventures rather than enduring triumphs. The Spanish victory was hardly convincing; fewer than 3,000 settlers resided in their network of missions and small villas when Texas became part of newly independent Mexico in 1821. That opened the door for American colonists, led by Stephen F. Austin; from 1821 to 1836, Texas's population had increased twelve-fold, replacing a venerable Hispanic culture with an impatient new American outlook. ❏

Incredible Journeys

No visitor ever had more reason to complain than the first European to penetrate the Texas interior. Along with 80 other survivors of an ill-fated attempt to colonize Florida, Álvar Núñez Cabeza de Vaca washed up on the Texas coast in 1528. Enslaved by Indians, forced to dig roots until his fingers bled, and bedeviled by clouds of mosquitoes, he subsisted on prickly pears and his skills as a faith-healer and primitive surgeon, finally leading his three surviving companions back into Mexico after eight years, thousands of miles, and incalculable miseries.

More than a century later, after claiming the lower Mississippi for France, Robert Cavelier, Sieur de La Salle, established Ft. Louis near Matagorda Bay in 1685. Learning of La Salle's incursion, the Spanish launched 11 land and sea expeditions to track him down and extirpate the settlement. When found, however, the fort had been sacked by Indians, its handful of survivors had gone mad, and La Salle had been murdered by his own men somewhere west of the Trinity River.

Opposite below: **The facade of Mission Espada, San Antonio.** *Photo Will van Overbeek*

Below: Champ d'Aisle, a French colony, engraving, c. late 1800s. In 1818, a French expedition founded Champ d'Aisle on the Trinity River, near present-day Liberty, but abandoned it in the face of Spanish threats. Texas State Library and Archives Opposite above: **Mural of Coronado's entrance into the Palo Duro Canyon by Ben C. Mead, 1934.** *Panhandle-Plains Historical Museum*

The San Jacinto Battle Flag, c. 1936. Brought to Texas by Kentucky volunteers led by Sidney Sherman, this was the Republic's only standard in the San Jacinto encounter. The priceless artifact has been restored since this photograph was taken and is displayed in the state capitol. Texas State Library and Archives, Austin

More than just the defining moment in Texas history, the heroic defense of the Alamo has staked a place in the national imagination. Texas's creation myth was born on March 6, 1836, when 1,500 assault troops commanded by the Mexican dictator Antonio Lopes de Santa Anna stormed the San Antonio de Valero mission, slaughtering the 183 defenders almost to the last man. The Alamo martyrs gave their yet-to-be-declared republic a rallying cry that echoed less than two months later, when Sam Houston and some 900 Texas Volunteers routed the Mexican army along the San Jacinto River and took Santa Anna prisoner. The victory was cast as a triumph of freedom-loving Americans over Mexican tyranny, an interpretation that cast a long shadow over Texas's relationship with Mexico and those of Mexican descent.

The reality was more complex. Many Anglo-Texans, including Stephen F. Austin, supported the liberal Mexican constitution of 1824, under which they hoped to become a state; many Tejanos (Mexican-Texans) supported the Anglo cause and fought alongside their Anglo neighbors. But such is the Alamo's iconic power

that controversy still haunts the question of how Davy Crockett died. A Mexican officer's diary, now accepted by most historians, describes his execution *after* the battle—enraging traditionalists who insist that John Wayne and Fess Parker played it the way it was. ❥

"TAKE THEM WITH THE BUT [SIC] OF YOUR GUNS, CLUB GUNS, & remember the Alamo… & club guns right & left, & nock [sic] there [sic] brains out. The Mexicans would fall down on there knees, & say me no Alamo…."

Narrative of Robert Hancock Hunter 1813–1822, From His Arrival in Texas, 1822, Through the Battle of San Jacinto, 1836

Battle of the Alamo— Travis Draws the Line by Hugo David Pohl, c. 1936. Pohl moved from the Midwest to San Antonio in 1924. Featured in this painting are Davy Crockett, the wounded Jim Bowie, and Colonel Travis, at right. *Ogden Museum of Southern Art*

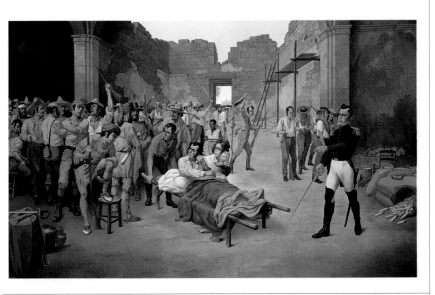

Portrait of Sam Houston by William G. M. Samuel, c. after 1856. Samuel used a well-known photograph of Houston for reference but replaced a somber shawl with one of the colorful *serapes* Houston favored. *Witte Museum, San Antonio*

The Republic of Texas was defined by the epic personality clash between its first elected president, Sam Houston, and his successor, Mirabeau Buonaparte Lamar. In 1836 Houston took the reins of a nation that was broke, unrecognized by any foreign power, menaced by Indian tribes, and still technically at war with Mexico. The pragmatic Houston pinched pennies, worked tirelessly for recognition, tried to make treaties with the Indians and peace with the Mexicans, and put all his hope in U.S. annexation. Lamar, a poet and historian, did virtually the opposite in pursuing his dream of a Texas empire—and lost to Houston in the next election.

Despite its split personality, the infant republic won full diplomatic recognition by England in 1842; fears of English influence eventually overcame the opposition to annexation, led by Abolitionists in the U.S. Congress. The Lone Star Republic, which had trebled its free population and increased its slave population eight-fold during its nine-year existence, exited on December 29, 1845, with perhaps its greatest

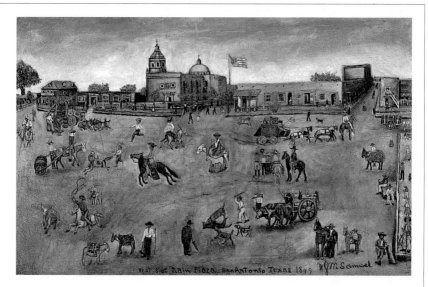

success: Texas negotiated to retain ownership of its vast public lands, much of it already earmarked to benefit public education. The payoff came in 1923, when oil discoveries in West Texas made the University of Texas the best-endowed public university in the nation. ❧

"THE REPUBLIC OF TEXAS WORKED A CURIOUS ALCHEMY WITH its citizenry, educated and untutored unlike. It took the sons and daughters of Tennessee, the Carolinas, Georgia, Mississippi, New York, France, and Germany and set its own ineffaceable stamp on their souls. The same process is still working in Texas today."

William Ransom Hogan, The Texas Republic, *1946*

West Side Main Plaza, San Antonio, Texas by William G. M. Samuel, 1849. An early Texas Renaissance man, Samuel was an Indian fighter, a solider in the Mexican War, and a deputy sheriff of San Antonio. His four views of its Main Plaza, painted for the old Bexar County courthouse, are a superb record of the town's social life. *The Witte Museum, San Antonio*

Down in Texas the cotton-field, the negro-cabins, drivers driving mules or oxen before rude carts, cotton bales piled on banks and wharves…

Walt Whitman, Leaves of Grass, 1855

Picking Cotton by José Arpa, 1929. This painting won the artist a $2,000 first prize in a 1929 San Antonio art competition. San Antonio Art League Museum Opposite above: Cotton Boll by Otis Dozier, 1936. A pioneering Texas modernist, Dozier grew up on an East Texas cotton farm. Dallas Museum of Art Courtesy the Estate of Otis Dozier

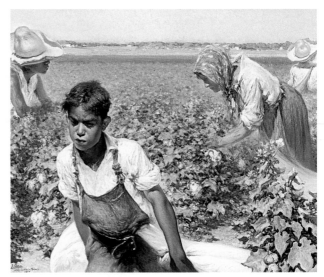

Forgotten Cotton

The romance of ranching and wildcatting has dictated Texas's self-image, but cotton has dominated the statistics. Cotton drove Texas's antebellum economic boom; by 1860 a third of its 600,000 inhabitants were slaves, and the planter-owners set the state's political agenda from their Brazos River mansions. After the Civil War, sharecropping replaced slavery; typically,

the land owner received three-quarters of the crop, but because he also provided credit, he often ended up with the sharecropper's quarter as well. Through the peak years of cattle ranching, the value of cotton crops was typically 50 to 100 percent greater than that of beef cattle. Even oil didn't dethrone King Cotton until the discovery of the East Texas oil field in 1930. The legacies of slavery and sharecropping were troubling to Texas historians promoting the state's egalitarian western identity, thus the Cotton Planter never entered the pantheon of Texas heroes. But the memories of cotton culture became deeply embedded, surfacing in such disparate forms as the "Country Blues" of Blind Lemon Jefferson and the folk visions of self-taught artists Willard "The Texas Kid" Watson and the Rev. Johnnie Swearingen.

Left: Terrell Cotton Gin with Kathleen Blackshear and J. P. Terrell by Ethel Spears, c. 1940s. The Chicago-born Spears studied and later taught at the School of the Art Institute there and exhibited at leading Eastern museums before retiring to rural Navasota in East Texas. *Collection Mr. and Mrs. William J. Terrell*

Below: House Mountain on the Llano by Frank Reaugh, c. 1900. Reaugh was enchanted with the "illimitable distance" of the open range. Dallas Museum of Art. Opposite: Charles Goodnight, c. 1870s. Photograph by W. D. Hornaday. Texas State Library and Archives

Cattle ranching was a driver of Texas's economy for a mere 25 years and a way of life for only a tiny fraction of residents. But the cattle industry's cultural legacy, clichés and all, can hardly be understated—perhaps because it offers mythical heroes as well as embodying the state's diversity and contradictions. The roots of Texas ranching are both Spanish and Southern. The *vaquero* was the first cowboy, and some South Texas spreads can be traced back to the Spanish *rancheros* of the

mid-1700s—a century before Anglos from the South and Midwest brought small herds into East Texas, fattened them on the rich grass, and drove them to market in New Orleans. Stray Spanish and southern cattle interbred to produce the fabled Texas longhorn; by the end of the Civil War, Texans were outnumbered eight-to-one by cattle, many of them unbranded "mavericks" running wild on the open range.

With Eastern consumers clamoring for beef, a few intrepid cattlemen like Charles Goodnight rounded up herds of strays, branded them, and set out for railheads in Kansas, blazing legendary trails across vast, uninhabited stretches of Texas, Oklahoma, and New Mexico. Cowboys endured both tedium and moments of terror as Indians attacked and herds stampeded. About a quarter of a million Texas cattle went north in 1866; by the time the great drives ended 20 years later, as many as 10 million head had made the journey. ⌐

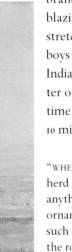

"WHEN ONE OF THESE OLD STEERS HEADED OUT OF THE herd for the brush he was ready to hook the liver out of anything that got in front of him. The horns were not for ornament. Oftener than otherwise it did no good to rope such a steer, as he would start fighting as soon as he felt the rope tighten...."

James Frank Dobie, A Vaquero of the Brush Country...
Partly from the Reminiscences of John Young, *1929*

Lord of the Plains

The "cowpunchers" who drove their herds to Kansas were a tough lot, but they wouldn't have gotten past the Red River without the cooperation—such as it was—of an even tougher breed. A hardy Spaniard with a robust dash of English blood, the Texas longhorn didn't become an identifiable breed until the outbreak of the Civil War. But eons of evolution couldn't have produced a survival machine better suited to life on the open range.

The King of Cattle

Charles Goodnight was a one-man history of the Texas cattle industry. Born the day before the Alamo fell, he was taught to track by Caddo Indians and served as a guide for the Texas Rangers before leading his pioneering drive up the Goodnight–Loving trail in 1866. Goodnight applied solid management principles to a chaotic business; every hand had a precise routine for any contingency, and when the day was ended they all queued up at another Goodnight innovation, the chuckwagon. Goodnight was one of the first trail drovers to understand the significance of barbed wire, invented in 1874. Within ten years, a law against fence-cutting effectively closed the open range and ushered in the era of the true cattle kingdoms—immense, million-plus-acre spreads often controlled by foreign investment syndicates. But "the Colonel" carried on, managing his own Panhandle ranch, consulting with Luther Burbank, and conducting experiments in wildlife conservation and scientific cattle breeding.

The Long Day by Tom Ryan, 1994. *Courtesy the artist. Opposite above:* Old Texas *by W. Herbert Dunton, 1929. Long-legged, hard of hoof, with a camel's tolerance for thirst, the lanky longhorn actually put on weight while on the trail. San Antonio Art League Museum. Opposite below:* **Palominos at Beggs Ranch in Post.** *Photo David Stoecklein*

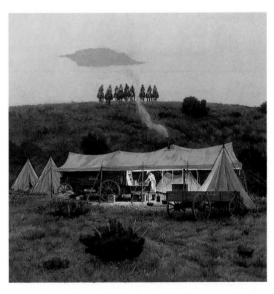

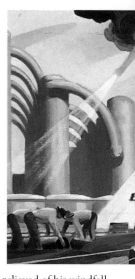

Below: Oil Field Girls by Jerry Bywaters, 1940. Jack S. Blanton Museum of Art, University of Texas Opposite above: East Texas of Today, After the Discovery of Oil by Olin Travis, 1936. One of two murals painted by Travis for the Hall of State, this depicts oil as giant, writhing figures suggesting the earth's vast energy resources. Dallas Historical Society

Oil transformed Texas: from a poor state into a rich state, from a rural state into an urban state. Texans had been drilling wells since just after the Civil War, but the oil era began in 1901 when the Spindletop gusher blew, in nine days spouting as much oil as the entire previous year's production. The find of the century, however, was the 43-mile-long East Texas Oil Field, a subterranean lake of oil discovered in 1930 when Columbus Marion "Dad" Joiner's rickety timber rig, Daisy Bradford No. 3, struck pay dirt.

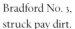

Joiner was soon relieved of his windfall, selling his leases for $30,000 to H. L. Hunt, who went on to become the nation's richest man. But the entire state shared the wealth. Sharecroppers left their tenant farms for the much better-paying work in the oil fields, leading a huge Depression-era exodus from the land. By 1980, Texas had three of the nation's ten largest cities, an economy that rustbelt states could only envy, and a lexicon enriched with "awl patch" terms like *wildcatter* and *roughneck*.

"FOR SURGING ENERGY, UNRESTRAINED OPENNESS, and diabolical conditions otherwise, Sour Lake was head and shoulders above anything Texas had seen up until that time.... The greater part of the field was soon a forest of derricks. As quantities of water are required to run a rotary drill, the slush which spread from these hundreds of wells and which was stirred up by the men working in it made the place a sight to behold.

"In Saloons, Sour Lake ranked high."

Charlie Jeffries, "Reminiscences of Sour Lake," 1946. Jeffries visited one of the first boomtowns, the appropriately named Sour Lake, in 1903.

Below: **Sunset behind a petrochemical plant in Houston.** *Photo Kaz Mori*

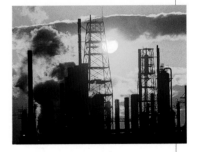

Chips: Of Salt and Silicon

In 1932, San Antonio promoter Elmer Doolin was so taken with the fried cornmeal chips he sampled in a local cafe that he borrowed a hundred dollars to buy the recipe. He fried up his own chips in his mother's kitchen, sold them out of the back of his Model T, and from that humble beginning built the mighty Frito-Lay Company. American snacking took a new twist.

Jack Kilby's chip merely changed the world. In the summer of 1958, Kilby was working at the Texas Instruments labs in Dallas on the problem of packing complicated electronic circuits into smaller packages. Kilby sketched an idea most of his colleagues considered wacko: fashion the components of complex circuits from a single

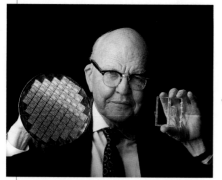

chip of silicon. Kilby's silicon-chip integrated circuit provided the technology for the pocket calculator (for which Kilby was awarded the first patent)—and the microprocessor brain of every computer on the planet. Today the digital revolution he precipitated has helped the Texas economy find life after oil; from Austin's Silicon Prairie to Dallas's Telecom Corridor, high-tech industries have become a buffer against oil-price-driven cycles of boom and bust.

"We were getting bored with the box."

Philip Johnson, Philip Johnson: The Architect in His Own Words, *1994*

The Postmodern Frontier

No one ever imagined that a gimmick like separating two identical 36-story office towers with a 10-foot-wide vertical slit would enable a landlord to charge premium rents for high-rise office space. That is, until avatar of modernism Philip Johnson convinced Houston developer Gerald Hines that his building could attain fiscal success by becoming an architectural landmark. The twin-spire Pennzoil Place was finished in 1975, three years before Johnson had the temerity to design a similarly bold postmodern conceit, the AT&T building in New York City. Pennzoil Place was ground zero for an explosion of commercial postmodernism, ushering in an era of high-rises surmounted by Chippendale pediments and neoclassical temples. Houston went on to acquire the world's first postmodern skyline, as signature architects like I. M. Pei and Cesar Pelli flocked to the new frontier. Johnson and partner John Burgee contributed two more Houston landmarks, including the nation's loftiest suburban high-rise: the 900-foot-tall, starkly isolated Transco Tower in the tony Galleria shopping area.

Philip Johnson transformed the Houston skyline with his and John Burgee's Nations Bank Center (center), dramatically stepped back in an echo of 1920s skyscrapers, and his Pennzoil Place, just left of center. *Photo Carolyn Brown*

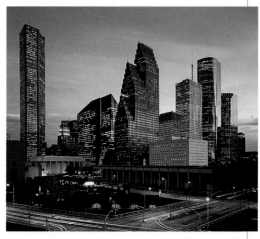

"Were I asked what is the national religion of the Texan people, I should answer none."

Matilda Houstoun, Texas and the Gulf of Mexico; or, Yachting in the New World, *1844*

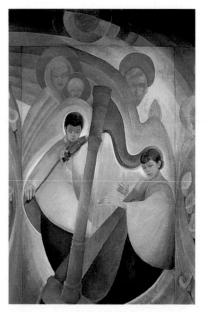

Almost as neatly as it can be bisected into sultry east and arid west, Texas can be divided into Protestant north and Roman Catholic south. The Spanish established missions around the territory in the late 1600s, laboring with great zeal but little success to convert the Tonkawa, Apache, and Caddo. Protestant evangelicals—principally Methodists—descended on the Republic of Texas with similar urgency, drawn by reports that its citizens were an appallingly impious lot; within a few years, raucous camp revivals were causing almost as much commotion as Texans' former iniquity. Baptists began to outnumber Methodists by the late 19th century, but Catholicism—dominant among German, Polish, and Mexican immigrants—also revived in the same period. Today Catholics and Baptists each represent about a third of all churchgoing Texans; their influence in the state's political and cultural life has never been stronger. ❥

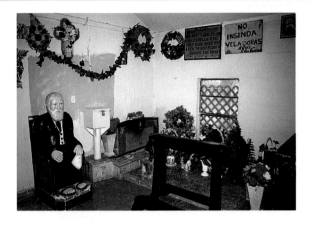

Left: The Don Pedrito Jaramillo shrine. *Photo Martha Grenon/Stock Options. Below: Sacred Heart Church #2* by David Bates, 1998. *Gerald Peters Gallery, Dallas. Opposite: Easter* by Grace Spaulding John, 1933. One panel of a four-panel mural on an explicitly Christian theme. The model for the harpist was the artist's daughter. *Collection Mrs. Patricia John Keightley*

Don Pedrito

The most venerated shrine in Texas lies just outside the tiny south Texas town of Falfurrias, at the unpretentious gravesite of Pedro "Don Pedrito" Jaramillo. Don Pedrito was a *curandero*—a traditional sort of faith healer/herbalist still found providing primary care, both spiritual and corporeal, for many south Texas Hispanics. Favoring peasant attire and transport (he always walked or rode a donkey), Don Pedrito healed uncounted thousands, often with subtle psychological insight rather than the incantations favored by many of his colleagues. Death seemed only to increase his powers. Although not formally canonized by the Catholic Church, Don Pedrito is worshiped as an unofficial saint by many in the region, a practice local clergy do not discourage.

Right: Flowers by Jim Love, 1965. *Photo Hickey-Robertson, Houston. Below: Untitled (Scatole Personali)* by Robert Rauschenberg, c. 1952. Born and raised in Port Arthur, Rauschenberg abandoned Abstract Expressionism early in his career and helped set a new course for contemporary art. *Both, the Menil Collection, Houston*

The Menil Monuments

Texas's important public works are often born of private largesse, but no benefactors have altered the cultural landscape quite as dramatically as John and Dominique de Menil. Refugees from Nazi-occupied France, the de Menils settled in Houston in 1942 and for the next half-century poured much of their fortune into civic causes and enlightened arts patronage. In a quiet neighborhood of gray clapboard houses near downtown Houston, the de Menils built a museum complex of astonishing catholicity and sophistication. Its centerpiece is the Menil Collection, designed by Renzo Piano, architect of Paris's controversial Centre Pompidou. The building exhibits a fraction of the more than 10,000-piece private collection, ranging from prehistory to Pop, with particular strengths in Byzantine icons and the Surrealist painters Max Ernst and René Magritte. Just down the street is another landmark, the octagonal Rothko Chapel, a monument

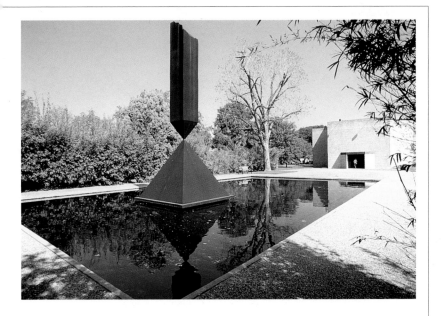

"What I admire, I must possess."

Dominique de Menil, 1983

to the de Menils' passionate ecumenicism, where 14 of Abstract Expressionist Mark Rothko's elegiac, almost monochrome last works invite nonsectarian transcendence. Within a block or two are several Menil Collection satellite galleries: another Piano building housing Cy Twombly's scriptlike abstract paintings; an installation of Dan Flavin's fluorescent-light sculptures in a renovated grocery store; and a concrete-and-glass Greek Orthodox chapel.

The reflecting pool at the Menil Museum and *Broken Obelisk* **by Barnett Newman, 1963–67. In the background is the Rothko Chapel.** *Photo Jay Griffis Smith/Texas Dept. of Transportation*

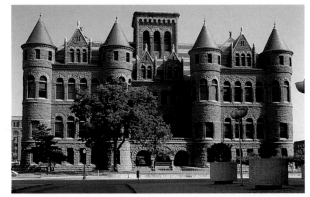

The Dallas County Courthouse. Designed in 1891 by Galveston architect Nicholas Clayton, this was originally a medical center. Affectionately known as Old Red, it is considered the best of the state's many Victorian buildings.
Photo Carolyn Brown

Eminent Victorians

Some of Texas's many Victorian county courthouses; architect and style noted:

Ellis County (Waxahachie)
*James Riely Gordon,
Renaissance Revival*

Fayette County (La Grange)
*James Riely Gordon,
Richardsonian Romanesque*

Hill County (Hillsboro)
*W. Clarke Dodson,
Second Empire*

Webb County (Laredo)
Alfred Giles, Eclectic

Wilson County (Floresville)
Alfred Giles, Italianate

The cities where most Texans now live retain a small-town civility. And for many Texans, the Victorian courthouses that still stand in the heart of countless small towns represent a way of life they're determined to preserve. Most were erected during a building boom that ran from 1881—when counties were allowed to issue bonds for new construction—to the end of the century. The architects tended to repeat a basic plan featuring a clock tower and four almost identical facades, but styles run the gamut of Victorian tastes.

Nicholas J. Clayton came to Galveston via Ireland and Cincinnati, where he had been a plasterer and marble carver. He found plenty of work as an

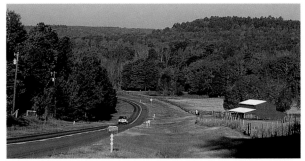

Left: Autumn color on a farm-to-market road in Cherokee County. These roads offer travelers some of the state's most scenic itineraries. *Photo Kevin Stillman/Texas Dept. of Transportation*
Below: Speed limit sign in rural Texas. *Photo Ripley Entertainment*

architect in Texas, building some 200 churches, houses, schools, and commercial buildings in Galveston alone. Considered Texas's most fluent master of the Victorian vernacular, Clayton could move effortlessly from Gothic Revival to Renaissance classicism without abandoning the orderliness underlying his picturesque details. ◢

Back Roads

Lavishly funded by the state legislature during the 1940s, farm-to-market roads were intended to spare Texas farmers the travails of muddy country lanes. Instead, the new rural highways became one-way streets as Texans left the land in epic numbers. The state kept building them anyway; today the farm-to-market roads account for more than half of Texas's vast highway system.

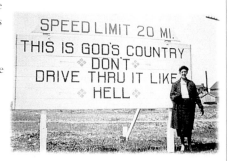

SPEED LIMIT 20 MI. THIS IS GOD'S COUNTRY DON'T DRIVE THRU IT LIKE HELL

Barton Springs, fed by the giant Edwards Aquifer, is Austin's chief recreational treasure. The city has recently acted to preserve water supplies and quality in the Barton Creek watershed. *Photo Will van Overbeek*

Bringing water to a largely arid land is a theme that runs throughout Texas history. Coronado stumbled across evidence of Native American crop irrigation in West Texas; the Spanish introduced a network of small irrigation canals called *acequias* to provide water for their San Antonio–area missions. With only one natural lake of any consequence (Caddo), Texans went to work building so many dams and reservoirs that their state now has more surface area under water than any other, Minnesota included.

But Texans can walk on their most important water resources: the nine major aquifers that lie beneath three-fourths of the state. In the 1930s, gasoline-powered pumps began drawing water from the vast Ogallala aquifer, spurring an agricultural boom only recently

threatened by profligate pumping. Rivaling the Ogallala in economic importance is Texas's least appealing waterwork, the 55-mile-long, refinery-lined Houston Ship Channel. Weary of shipping their goods through Galveston, Houstonians began dredging the Buffalo Bayou in the 1870s; work continued in stages into the 1960s. ◣

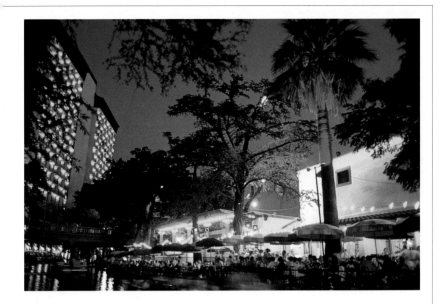

Paseo Del Rio

The San Antonio River was once considered such a civic nuisance that plans were proposed to convert it into a sewer. But architect Robert H. Hugman persuaded San Antonio to transform the oft-flooding eyesore into a South Texas Venice. Completed in 1941, the Paseo del Rio, or River Walk, is a 2.5-mile stretch of river lined with tropical foliage and cypress-shaded promenades. Sightseeing barges and water taxis wend past riverfront cafes and luxury hotels. Meandering below street level through the heart of downtown, a world apart in its lush, romantic ambience, the River Walk is eclipsed as a tourist attraction only by its celebrated neighbor, the Alamo.

River Walk at night. The cobblestone paths of the walk and the stone stairways accessing it were built by WPA crews in the 1930s.
Photo Will van Overbeek

New Deal murals were commissioned for more than 60 Texas post offices, often in small towns; those that survive showcase fine examples of 1930s regionalist painting. The federal programs ended in 1943, and since then, Texas's most notable public art has relied on the initiative of a few determined individuals. John Biggers, founder and long-time head of the art department at Texas Southern University, has painted 23 murals in six decades, many for public buildings in and around Houston. Luis Jimenez's exuberant, neo-Baroque fiberglass sculptures reinterpret Western myths—and have sparked controversy—in cities throughout the state. For sheer ambition, however, nothing can compare with the late Donald Judd's Marfa project. ◢

Cattle Drive by Robert Summers, 1995, in Dallas's Pioneer Plaza. *Photo Will van Overbeek Right: Fiesta Dancers* by Luis Jimenez, 1990. The El Paso-born Jimenez makes muscular, polychrome sculptures of *vaqueros* and other working-class heros, rewriting Western myths from a Hispanic perspective. *Photo Jay Griffis Smith/Texas Dept. of Transportation*

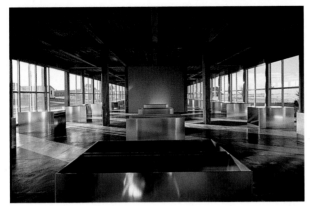

100 untitled works in mill aluminum by Donald Judd, 1982–86. This permanent installation casts minimalism in a lustrous new light: the immaculately machined surfaces register each inflection of the endlessly changing West Texas skies. *The Chinati Foundation, Marfa. Photo Todd Eberle. Below: Houston Police Officers Memorial by Jesús Bautista Moroles, 1992. Moroles has created several public commissions and sculptures using Texas hill country granite. Photo Robert McClain & Co., Houston*

The Marfa Project

Marfa (pop. 2,400) has seen a lot for a little West Texas town. Not only did Elizabeth Taylor and the cast of the film epic *Giant* bunk at the Paisano Hotel while shooting just up the road, but the area also hosts a phenomenon known as the Marfa Lights, a routine display of unexplained—some say otherworldly—luminescence. But nothing prepared Marfans for the arrival of art world luminary Donald Judd in the late 1970s. Judd took over an abandoned army base, filling empty warehouses with rows of his polished aluminum cubes and an entire pasture with massive concrete rectangles. The installation is venerated as a high shrine of Minimalism by art pilgrims from all over the world. It's a trip worth taking.

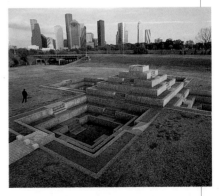

Stephen F. Austin by an unknown German artist, painted in New Orleans in 1836 for Austin's sister, Mrs. Emily Perry. In 1825, Austin had written, "It is...a matter of greatest importance, to authorize the emigrants to bring in their Slaves and Servants...." *Texas State Library and Archives*

Like his counterparts in the realms of commerce, the Texas politician rode out of the mythical frontier, a squinty-eyed backroom gunslinger with unflinching electoral instincts, itching to shoot down less focused ideologies with the classic Texas parliamentary put-down: "That dawg won't hunt." In reality, the three giants of Texas politics—Stephen Austin, Sam Houston, and Lyndon B. Johnson—were chronic doubters, complex men whose internal conflicts ran at least as deep as their convictions. ♪

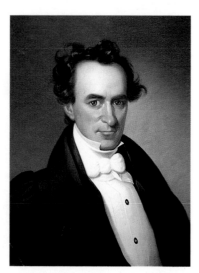

True Doubters

Stephen F. Austin believed that industrious Anglo-Americans could transform Spanish Texas into "the garden of North America." And though he didn't believe in slavery, he reluctantly concluded that the colony couldn't prosper without allowing it. The success of his policy upset Austin's plans for Texas to become a state under liberal Mexican law; as slave owners flooded in, the burgeoning Anglo population demanded full independence. It proved costly in the long run as well: Texas was saddled with a desperately poor agrarian economy until the 1940s, and a still-persistent inferiority complex.

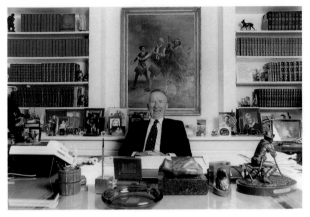

H. Ross Perot in his office. Founder of the data-processing giant Electronic Data Systems and one-time director of General Motors, Perot rode his wealth and reputation as a Texas maverick into the 1992 presidential election against George Bush and Bill Clinton, and came away with 19 per-cent of the popular vote. The only true doubter in Perot's campaign may have been his running mate, Admiral James Stockdale, who won-dered in a speech, "Who am I? Why am I here?" *Dallas Morning News.* Photo *David Woo*

If there is one essential Texan, it has to be Sam Houston—first president of the Lone Star Republic, the new state's first U.S. senator, and governor on the eve of secession. But Houston believed in everything his compatriots didn't. He sought peace with Texas Indians and advocated their rights to the land they occupied. While his rivals floated fantasies of empire, Houston believed the republic should pursue annexation. A staunch Unionist, he warned against secession; when he refused to swear loyalty to the Confederacy, he was removed from office.

"YOU MAY, AFTER THE SACRIFICE OF COUNTLESS MILLIONS of treasure and hundreds of thousands of lives, as a bare possibility, win Southern independence…but I doubt it."

Sam Houston, 1860

"Hey, Hey, LBJ"

Raised dirt-poor on a hill country farm, Lyndon Baines Johnson embodied for the world the larger-than-life, wheeling-and-dealing character of Texas. Yet LBJ was the consummate New Dealer, a master legislative tactician who forced the South to accept civil rights legislation, then launched the Great Society and the War on Poverty. He first considered the Vietnam conflict a distraction from his domestic agenda, but came to agonize over escalating involvement. In the end, however, he couldn't quite forget a Texas icon. The Christmas 1965 bombing halt gave hope for peace, but LBJ resumed the air strikes with a sacred invocation: "Vietnam is like the Alamo." From that point on his critics were as unrelenting as his determination not to back down—and his presidency was doomed.

"IF AMERICANS MUST REMEMBER THE ALAMO, LET'S remember that gallant men died needlessly in that old mission....To persevere in folly is no virtue."

New York Times *editorial, 1967*

Lyndon B. Johnson by Steve Yuryani, 1971. Montreal sculptor Yuryani made this caricature of LBJ as a lawman from fiberglass and wire. He may have been inspired by an editorial cartoon from the *Wilmington News Journal* titled "Alright, You Editorial Cartoonists, *Draw!*" This was drawn for the 1971 annual meeting of the editorial cartoonists association, held at the LBJ Ranch in Johnson City. *Lyndon Baines Johnson Library and Museum. Photo Henry Groskinsky*

Good Ol' Gals

Texas may have been hell on women and horses, but the state's distaff politicians have been bashing gender barriers for generations. Elected to the first of two terms in 1924, Governor Miriam "Ma" Ferguson continued the populist policies of her impeached husband, "Farmer Jim" Ferguson. Frances "Sissy" Farenthold bore the banner of Texas liberalism with a narrowly unsuccessful bid for governor in 1972, while Barbara Jordan—the first black woman elected to Congress from a southern state—became the nation's eloquent conscience during Watergate. Her stirring performance led to her selection, in 1976, as the first woman to deliver the keynote address at a Democratic national convention. Democrat Ann Richards, with her ossi-

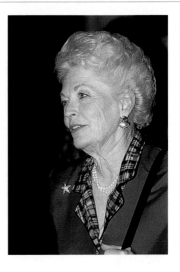

Above: **Ann Richards.** *Photo Kevin Stillman/Texas Dept. of Transportation* *Left:* **Barbara Jordan. In 1967, Jordan was elected Texas's first black state senator since Reconstruction.** *Photo Corbis-Bettmann*

fied Texas coif and country-gal wit, achieved national prominence after her election as governor in 1990. Current Republican Senator Kay Bailey Hutchison—a former University of Texas cheerleader—and political humorist Molly Ivins, whose pen has filleted many a conservative, carry on the tradition of gender equality from both sides of the party line.

Nestled by Tom Ryan, 1987. The house in Ryan's painting is an adobe ranch building. *Courtesy the artist. Below:* The Carraro House in Kyle, designed by David Lake and Ted Flato, 1990. The spacious breezeway and porch are borrowed from the log cabins of Texas's earliest Anglo settlers, updated with the unadorned industrial materials found in modern Texas barns and agricultural warehouses. *Photo Hester+Hardaway*

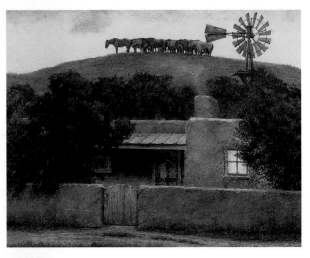

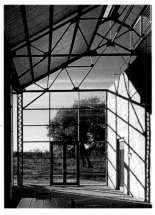

Each successive wave of settlers left an architectural legacy that, even if modest, inspired some of Texas's most acclaimed homes. Many Spanish colonists built simple mud-and-wattle *jacals*; those who could afford better built more elaborate, flat-roofed adobe houses—a mode of construction that persisted in West Texas well into the 20th century. The "dogtrot" house (two log "pens" joined by a covered breezeway), a southern convention introduced by Anglo-

American settlers in the 1820s, proved particularly well suited to the sweltering Texas coastal plains. A decade or two later, German immigrants introduced *fachwerk*, half-timbered construction filled with native hill-country limestone.

The dignified simplicity of the Greek Revival style, which expressed both the aspirations and modest means of the new Texas Republic, remained the dominant influence throughout statehood and secession. Fine surviving examples include the Governor's Mansion in Austin and a number of houses and mansions in the East Texas town of Jefferson, built by planters and shippers enriched by the antebellum cotton economy. Reconstruction ushered in the Victorian era and a period of decorative abundance. Massed Queen Anne turrets became ubiquitous throughout the state, as did the kind of ornate gingerbread trim still preserved on numerous houses in Galveston's East End Historic District.

Ranchos Los Vidas near Pearsall, 1997, is typical of O'Neil Ford's work. Ford married regionalism and modernism, combining handcrafted details, native materials, and classic warm-weather architecture with innovative modular construction techniques. *Photo Paul Bardagjy*

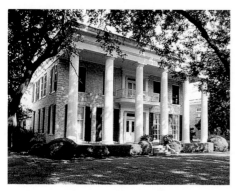

Shortly before the first World War, Prairie Style homes brought Texas domestic architecture into the modern era—a trail blazed by prolific El Paso architect Henry Trost, who adapted Frank Lloyd Wright's Midwestern aesthetic to the southwestern climate. As the 20th century progressed, however, many of Texas's best modern architects moved forward with eyes fixed firmly on the past. In the 1920s and 30s, David R. Williams built clean-lined interpretations of

Above: The Governor's Mansion in Austin, an 1856 Greek Revival building, used Austin-made bricks and locally grown pines in its construction. Among the period furnishings on display are Sam Houston's bed and Stephen Austin's desk. *Photo Gay Shackelford/Texas Dept. of Transportation. Right:* The Frederick Beissner House, an 1887 Victorian in Galveston. *Photo Mary G. Crawford/Stock Options*

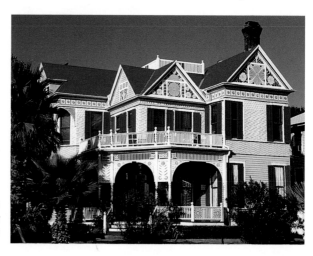

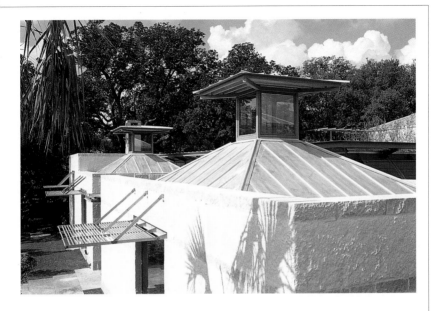

German hill country homes. Williams's protégé, O'Neil Ford, considered Texas's greatest regionalist and perhaps its greatest architect, combined Spanish and Mediterranean motifs with a stripped-down, exquisitely crafted modernism. The tradition continues with San Antonio partners David Lake and Ted Flato, both trained in Ford's firm, who have built award-winning postmodern houses using local stone, corrugated metal roofs borrowed from agricultural vernacular, and "dogtrot" breezeways. ⌡

The Pace House in San Antonio, designed by David Lake and Ted Flato, 1995. *Photo Hester+Hardaway*

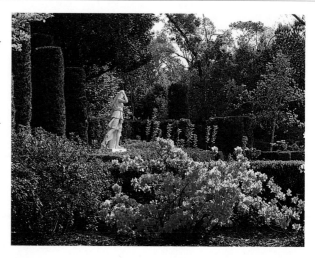

Garden at Bayou Bend. *Below:* A portrait of Ima Hogg hangs in the foyer of her home, Bayou Bend. *Both photos, Nicholas DeVore III/ Photographers Aspen Opposite:* Lady Bird Johnson's National Wildflower Research Center. *Photo Gay Shackelford/ Texas Dept. of Transportation*

Ima Hogg's Heaven

Texas Governor James Stephen Hogg just hadn't thought it through when he named his daughter after the heroine of her uncle's Civil War poem. But Ima Hogg, born in 1882, matured into a woman of unimpeachable taste, an indefatigable philanthropist and arts patron whose passions included music, architecture, and landscape design. In 1928, architect John Staub, Houston's preeminent designer of gracious private homes, built "Miss Ima" a pale pink stucco mansion in a masterful synthesis of American Federal, English Regency, and Louisiana Creole elements—a style Ima called "Latin Colonial." Filled with her superb collection of American art and

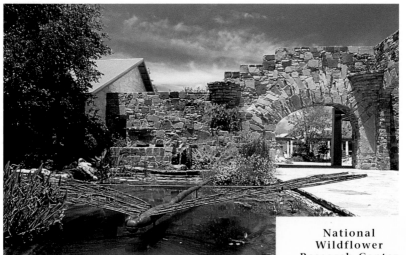

antiques, the house, known as Bayou Bend, is now open to the public as the decorative arts annex of the Museum of Fine Arts–Houston. Equally celebrated are Bayou Bend's 14 acres of formal gardens, conceived by Staub and Miss Ima as an extension of the house. Five decades in the making, wrapped by thick woodlands along the bend of the Buffalo Bayou, the eight distinctive gardens include a terraced grass amphitheatre, a butterfly-shaped parterre of camellias and azaleas, an English-style garden with Japanese boxwoods in a scrolled pattern, and topiaries of Texas animals selected by Hogg shortly before her death in 1975.

National Wildflower Research Center

Founded in 1982 by Lady Bird Johnson and actress Helen Hayes, the National Wildflower Research Center, a 42-acre preserve near Austin, offers native-species enthusiasts a wildflower meadow, nature trail, and 23 theme gardens devoted to Texas flowers and plants. Here Texas chauvinists are urged to "go green"; the center's research projects and educational programs vigorously promote water-saving and environmentally friendly native species over pesticide-needy imports.

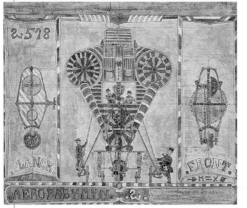

Aero Babymyn by C. A. A. Dellschau, c. after 1908. Discovered in a Houston dump in the 1960s, pages from Dellschau's extraordinary note-books have become hot properties in the folk art market. *The Witte Museum, San Antonio Right: Jimbo Man by Reverend J. L. Hunter, 1992. Webb Gallery, Waxahachie*

Given the long struggle of formally trained Texas artists to win recognition, it's not surprising that the state's extraordinarily rich legacy of folk art has only recently found attention. And for that reason, Texas's most gifted folk artists have been true outsiders, isolated by poverty, racism, or mental disabilities—or simply by a unique, passionately held vision. Former sharecropper Ezekiel Gibbs was in his eighties when he took up art in 1972, but his stunning pastel-and-watercolor reminiscences of country life combined Fauve color with a Matissean gift for abstract design. Working in a Houston garret early in the 20th century, a German immigrant butcher named C. A. A. Dellschau filled

dozens of notebooks with detailed watercolors of fantastic flying machines powered by mysterious technology. From the prisons where he has spent much of the last 20 years, Henry Ray Clark creates intricate, tapestry-like science-fiction vignettes in ballpoint on manila envelopes. On a table in his tiny Beaumont church, Xmeah ShaElaReEl paints surrealistic images of ferocious angels and an imminent apocalypse. And Texas's best-known folk artist, Eddie Arning, was a schizophrenic who produced a vast oeuvre of pastel drawings—often marvelously geometric interpretations of magazine illustrations—while confined to a mental ward.

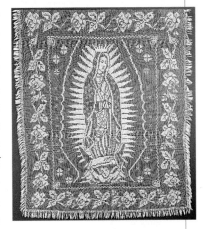

Crocheted bedspread depicting the Virgin of Guadalupe, c. 1930, South Texas. The unknown needlework artist chose a favorite Mexican-American subject. *San Antonio Museum of Art*

Mexican-American folk art, by contrast, has always been integrated into the life of the community, its traditions and craftsmanship passed from generation to generation. *Retablos* (religious paintings on tin) and *santos* (statues of saints) are familiar terms in most Texans' decorating vocabulary. But to see what they really mean requires a trip to the west-side *barrios* of San Antonio, where yards adorned with flower-festooned cement shrines called *capillas* display glassed-in pictures of family members alongside brightly painted, glittered-and-tinseled little *santos*. ❒

As early as the 18th century, travelers had identified the humble corn tortilla as the inescapable staple of Texas cooking. But the state's signature cuisine wasn't created until 1887, when Tula Borunda Gutierrez of Marfa's Old Borunda Cafe (only recently closed) whipped up the first combination plate—tortilla-wrapped enchiladas and tacos with rice and beans—on her mesquite-fired stove. "Tex-Mex" spread to San Antonio by the turn of the century, and early franchises had appeared by the

Hellfire and Damnation hot sauce. *The El Paso Chile Co. Right: Chili Stand* by Clara Caffrey Pancoast, c. 1940s. A writer by profession and a student of José Arpa, Pancoast painted this after chili stands were banished from the streets of San Antonio. *The Witte Museum, San Antonio. Opposite:* Pork rib barbecue at Mt. Zion Missionary Baptist Church, Huntsville. *Photo Will van Overbeek*

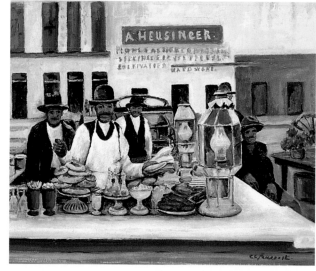

1930s. As beloved by Hispanics as it is by Anglos and foreigners, Tex-Mex offers the state's most ecumenical dining experience. ⌐

Grilling Rites

Barbecue may be an all-American cuisine (at least throughout the South and Southwest), but in Texas it's a *religion*. The supreme manifestation of barbecue is a subject of intense debate, with the subtleties of hickory vs. mesquite wood, direct vs. indirect heat, firm meat texture vs. crumbling, and sauce vs. plain argued with doctrinaire fervor. True believers insist that no brisket is worthy unless it's served on butcher paper—no plastic plates, please!—and that side dishes other than an onion slice and a piece of white bread are rank heresy.

Barbacoa de Cabeza

A traditional Sunday breakfast in the lower Rio Grande Valley.

1 whole beef head
3 whole garlic heads, separated
2 bunches cilantro
4 onions

Dig a hole 2 feet deep and build a wood fire in it. Wrap the head in a paper sack with onions, garlic, and cilantro, then wrap the paper sack in burlap. When the fire has burned to coals about 6 inches deep, place the head in the pit, bury it, and build a mesquite wood fire on top. Cook for 12–18 hours, then dig up, remove the meat from the skull, and serve with tortillas. (Note: There are many variations on preparation of the pit, which greatly affects cooking time, and on wrapping the head—it's best to consult an expert.)

Adapted from traditional South Texas recipes

A night game between archrivals Houston Memorial and Houston Northbrook. *Photo Geoff Winningham. Below:* Dallas Cowboys quarterback Troy Aikman lines up behind center. *Photo Jim Zerschling*

Friday Night Fever

If Dallas Cowboys fans are considered among the nation's more sedate Sunday spectators, that's probably because many are still hoarse from Friday night. In a state where Super Bowl

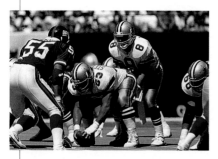

victories are soon forgotten, teams that win the high school state championship can still expect virtual immortality. The days when flush oil towns "recruited" talented players from less affluent districts are long gone, but vaunted programs like that of Odessa Permian High School continue to inspire controversy with their zealous pursuit of gridiron glory. (Permian's Panthers, inspired by a quasi-mystical team spirit

locals call "Mojo," have "won state" six times in the last 35 years.) The purest passion for the game is found at schools too small to field eleven-man squads, where a fast-paced variant called six-man football can draw huge crowds.

Texas girls, too, now compete for state titles in sports ranging from basketball to soccer, but that hasn't diminished enthusiasm for a time-honored tradition: the drill team. All such teams follow in the well-choreographed foot-steps of the Kilgore College Rangerettes, who in 1940 staged the first precision drill team halftime performance. Dressed in short skirts, white cowboy boots, and saucily cocked white hats, the high-kicking Rangerettes exude an All-American appeal that stops just short of sex.

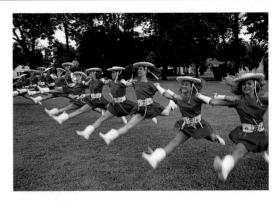

The Kilgore Ranger-ettes, whose motto is "Beauty knows no pain," execute a flying split. Legendary founder Gussie Nell Davis, who brought show-biz snap and sizzle to halftime, is so venerated by Texas football fans that she recently joined Texas's greatest gridiron heroes in the Cotton Bowl Hall of Fame. *Photo Will van Overbeek*

"AND THEN IT RISES OUT OF NOWHERE, TWO ENORMOUS FLANKS of concrete with a sunken field in between. Gazing into that stadium, looking up into those rows that can seat twenty thousand, you wonder what it must be like on a Friday night, when the lights are on and the heart and soul of the town pours out over that field, across those endless plains."

H. G. Bissinger, describing Odessa Permian High School's
$5.6 million football stadium in Friday Night Lights:
A Town, a Team, and a Dream, 1990

"Our State Fair Is a Great State Fair"

In 1986, the 100th anniversary Texas State Fair in Dallas drew almost four million visitors, making it America's biggest-ever state fair. So archetypal that the movie *State Fair* was set there in 1962, the fair features a sprawling midway, artery-clogging delicacies like corny dogs (native to the Texas State Fair) and Belgian waffles, acres of exhibits ranging from luxury cars to farm machinery, and its famous official greeter, Big Tex—a 52-foot-tall, slightly articulated talking mannequin.

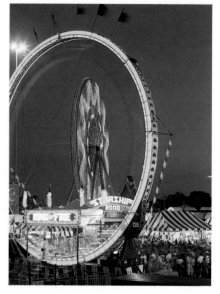

But the fair's real greatness lies in its indestructible small-town traditions: the pie-bakeoffs and displays of prize-winning preserves, the horse shows and sheep dog demonstrations, the procession of 4-H'ers with their immaculately groomed Herefords and Angora goats.

Left: Renowned for his drawling, mechanized "Howdy," Big Tex wears size 70 boots and a 75-gallon hat. His shirt requires 121 yards of cloth and his jeans are sewn from a mere 102 yards of denim. *Above:* The Lone Star ferris wheel, seen through another ride at the fair. *Both photos, Carolyn Brown*

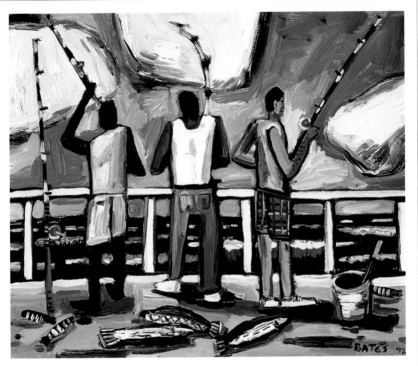

Huntin' 'n Fishin'

Texas got its first major league professional sports team late, in 1960. Before then, sports for grown men meant just one thing: hunting and fishing. And the beginning of the hunting season—traditionally marked by the start of dove season in September—remains as big a season opener as there is in Texas sports. If you're even thinking about running for governor, an opening-day appearance is mandatory.

Flagship Pier by David Bates, 1992. Bates studied art at Southern Methodist University and has worked mainly in his hometown of Dallas. *Berggruen Gallery, San Francisco*

James Dean in *Giant*, 1956. *Photofest. Opposite:* John Wayne in *The Alamo*. Wayne stayed in character long enough to see the trail-drive heroics of *Red River* (1948) evolve into the subtle exploration of frontier racism in *The Searchers* (1956). *Photofest*

Texas on Stage and Screen

Hollywood's love affair with Texas is as old as the film industry. Westerns set in Texas were once Hollywood's dominant genre, and the box-office giants were either real Texans like Gene Autry and Tex Ritter, or reel Texans like Tom Mix and John Wayne, who many audiences perceived as Texas natives. *Giant* (1956) portrayed the clash of the old (cattle) and new (oil) Texas, while *Hud* (1963) introduced Paul Newman as a new breed of cowboy antihero. The small-screen *Dallas* (1979–91) became a campy international sensation by featuring "awl bidness" wheeler-dealer J. R. Ewing in a ranch setting and Texas's glitzy urban milieu. Images of postmodern Houston have ranged from the ridiculous (*Urban Cowboy*, 1980) to the sublime (*Terms of Endearment*, 1983). Made-in-Texas indie favorites include *The Texas Chainsaw Massacre* (1974) and *Slackers* (1990).

> *"Texans have two pasts, one made in Texas, one made in Hollywood."*
>
> *Don Graham,* Cowboys and Cadillacs:
> How Hollywood Looks at Texas, 1983

Icon Meets Icon

A French filmmaker shot the first Alamo epic on location in 1911. By the time John Wayne ambled into South Texas to make *The Alamo* (1960), the story was old hat, but the Duke's commitment to it broke new ground. Producer-director-star (he played Davy Crockett, of course) Wayne, who had been trying to put together the project since the late 1930s, spent $12 million making what was then the biggest-budget movie ever. Dismissed by critics, his version nevertheless fudged Texas history less than most, toned down the subject's inherent racism, and earned 11 Oscar nominations.

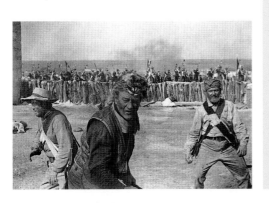

Reel-Life Texas

Red River Howard Hawks's trail drive epic. John Wayne and Montgomery Clift get the herd from Texas to Kansas.

The Searchers John Ford classic about a man bent on killing his disgraced niece, an Indian captive.

Giant Film version of Edna Ferber's tale, with Rock Hudson and James Dean.

Hud Paul Newman as the caddish cowboy who loves 'em and leaves 'em. Based on Larry McMurtry's first novel.

Bonnie and Clyde 1930s outlaws (Warren Beatty and Faye Dunaway) reborn as 1960s folk heroes.

The Last Picture Show Loss of innocence in a small town; Peter Bogdanovich introduced Cybill Shepherd.

The Getaway Underrated Sam Peckinpah chase set in modern West Texas.

Texas Chainsaw Massacre Tobe Hooper's cult classic set the standard for postmodern horror flicks.

Tender Mercies Robert Duvall's Oscar-winning role as a down-and-out country singer.

Terms of Endearment Tearjerker set in contemporary Houston; from another McMurtry novel.

Paris, Texas Wim Wenders directed this quirky homage to *The Searchers*, with Harry Dean Stanton.

Right: Janis Joplin in concert. *Photo Corbis-Bettmann. Below:* Leadbelly had his greatest impact on white folksingers—among them Port Arthur's Janis Joplin, who played acoustic folk blues in Texas coffeehouses before moving to California and creating her psychedelic blues-rock. *Center for American History, University of Texas*

Cut Texas from the score, and American music would still exist—though in a considerably abridged form. From blues to country to—surprise!—opera, Texas has produced a remarkable roster of musical mavericks who in standing defiantly alone have profoundly influenced America's mainstream beat. ♩

Deep Ellum Blues

Blind Lemon Jefferson, born in rural East Texas in the 1890s, was a small-town street musician before migrating to the domino parlors and nightclubs of Dallas's Deep Ellum district (Texas's Beale Street) in the mid-1910s. There he met Huddie "Leadbelly" Ledbetter, an irascible 12-string-guitar virtuoso who became Blind Lemon's "lead boy" until he went to prison for murder. Jefferson went on to record dozens of hits for Paramount in the 1920s, including his signature "Black Snake Moan." Eventually freed, Leadbelly won national recognition with songs like "Scottsboro Boys."

Grand New Opry

Not content merely to reprise Wagner and Verdi, the Houston Grand Opera has world-premiered some of the most avant-garde operas of our time. Among them: John Adams's *Nixon in China*; Stewart Wallace and Michael Korie's *Harvey Milk*; Philip Glass and Doris Lessing's *Making of the Representative from Planet Eight*; and Michael Daugherty and Wayne Kostenbaum's *Jackie O!* HGO productions are sought around the world. Just how far Texas culture has come—from self-conscious importer to self-confident exporter—was highlighted when HGO's celebrated production of *Porgy and Bess* opened to rave reviews at Milan's venerable La Scala in 1996.

A scene from Houston Grand Opera's production of Philip Glass and Doris Lessing's *The Making of the Representative from Planet 8,* Act I, at the Wortham Theater Center. *Houston Grand Opera Archives. Photo Jim Caldwell*

Not Nashville

The state's small towns have produced a phenomenal number of country music giants. Gene Autry (born in Tioga) brought West Texas cowboy music to Hollywood in the 1930s and became America's most popular singer; Bob Wills (born near Kosse) and His Texas Playboys blended the sounds of big band, blues, jazz, steel guitar, and drums to create western swing. Ernest

Tubb (from Crisp) and Lefty Frizzell (Corsicana) borrowed a bit from Wills to pioneer the jazzy, guitar-based honky-tonk sound in the 1950s. In the early 1970s Willie Nelson (Abbot) and Waylon Jennings (Littlefield) challenged Nashville's conformity by merging country and counterculture; joined by such fellow "outlaw" artists as Jerry Jeff Walker and Cosmic Cowboy Michael Murphy, they made Austin the capital of alternative country music. That legacy lives on in Austin's fecund live music scene, noted for nurturing such singer-songwriters as Nanci Griffith and the late Townes Van Zandt, as well as in the quirky lyrics and exotic, swing–blues–honky-tonk style of Lyle Lovett.

Czech-Mex

Nothing expresses Texas's multicultural vitality more vividly than the music known as *conjunto*. Beginning in the late 1920s, *conjunto* pioneer Narciso Martinez borrowed the polkas and mazurkas of South Texas's Czech and German farmers, added Latin rhythms, and transcribed the music for a hybrid ensemble that matched European accordion with Mexican 12-string guitar. The infectious, oom-pah *conjunto* beat has remained a Texas music staple, both with more traditional bands as well as pop crossovers like the late *tejano* diva Selena.

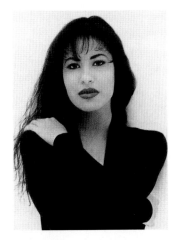

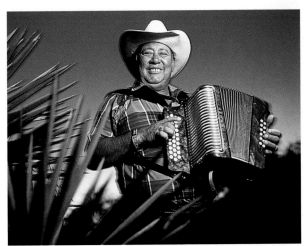

Above: Selena Quintanilla Perez. *Photo Maurice Rinaldi/Photofest*
Left: Tony de la Rosa, the "godfather of *conjunto*." In the late 1800s, German-made accordions were imported into northern Mexico and Texas, where they often accompanied German and Czech immigrants' brass bands. *Conjunto* was born when the accordion was introduced to Mexican rural string bands. *Photo Will van Overbeek*

Thanks to a triumvirate of close literary friends—Walter P. Webb, J. Frank Dobie, and Roy Bedichek—Texas is a place where mythology often trumps history, even shapes it. Beginning with *A Vaquero of the Brush Country* in 1929, folklorist Dobie penned 25 books of tales rooted in Texas's land and past, inspiring generations of Texas writers to look for epic themes close at hand. Historian Webb's *The Great Plains* (1931) recast Texas as a western rather than a southern state; *The Texas Rangers* (1935) cast the gun-packing man of action as the frontier's supreme civilizing agent. Bedichek was the czar of Texas high school athletics when he wrote his first book at age 68, but *Adventures with a Texas Naturalist* (1947) remains the classic

Above: Walter Prescott Webb at a barbecue, c. 1957. Photograph by Russell Lee. Center for American History, University of Texas. Below: Jacket art by Shannon Stirnweis for Lonesome Dove, *1985. McMurtry finally did take on Texas's mythic past, but the Pulitzer Prize–winning* Lonesome Dove, *based on the life of rancher Charles Goodnight, revisited the frontier with irony and unsparing explicitness. Courtesy George Corsillo*

"'SON, THIS IS A SAD THING,' AUGUSTUS said. Loss of life always is. But the life is lost for good. Don't you go attempting vengeance. You've got more urgent business. If I ever run into Blue Duck I'll kill him. But if I don't, somebody else will. He's big and mean, but sooner or later he'll meet somebody bigger and meaner....Or he'll just get old and die.'"

Larry McMurtry, Lonesome Dove, *1985*

paean to a mythic land. Those who don't see Texas literature as an exclusive men's club can cite Katherine Anne Porter, whose novels (*Pale Horse, Pale Rider; Ship of Fools*) range farther from Texas soil.

Writing as an essayist, Larry McMurtry emerged as the sharpest critic of the Texas mythmaking embodied by Webb, Dobie, and Bedichek. As a novelist, McMurtry practiced what he preached. *The Last Picture Show* (1966), an unsentimental elegy to a small-town way of life, prefaced an urban trilogy that included *Terms of Endearment* (1975). ❧

Left: Katherine Anne Porter. Born and buried in tiny Indian Creek, Porter was often snubbed by Texas's male-dominated literary establishment; in 1939 her nationally acclaimed *Pale Horse, Pale Rider* was passed over for the state's top literary award in favor of J. Frank Dobie's Texas folklore compendium, *Apache Gold and Yaqui Silver.* It's no longer heresy, however, to consider her Texas's greatest writer. *Center for American History, University of Texas. Below:* Sandra Cisneros. *Photo Dorothy Alexander*

Voices from the Border

La Frontera—the bicultural swath along the course of the Rio Grande—has become Texas's most vibrant literary colony. MacArthur award winner Sandra Cisneros (*Woman Hollering Creek,* 1991) of San Antonio writes movingly about the experiences of Hispanic women in an Anglo-dominated culture. In a series of novels known as "The Klail City Death Trip," Rolando Hinojosa wryly exposes the complicated ethnic politics of the Rio Grande Valley. And National Book Award winner Cormac McCarthy, an El Paso resident since the early 1980s, has been hailed as the border's Faulkner (*All the Pretty Horses,* 1992).

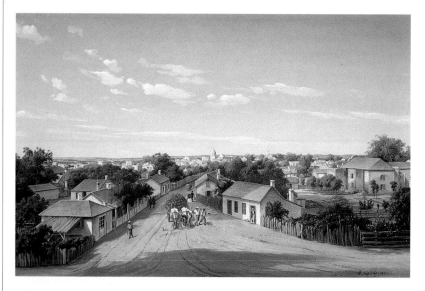

The mid-19th-century romantic malady known as "Texas fever" had a particularly virulent Teutonic strain. Yearning for political freedom, Germans of the 1840s devoured guidebooks, novels, and poems extolling the new Texas Republic; *"Geh mit ins Texas"* ("Go with us to Texas") even became a common greeting in parts of Germany. When Dresden Royal Academy of Fine Arts graduate Hermann Lungkwitz arrived at Galveston in 1851, he joined German immigrants already numbering about 30,000—almost a fifth of the state's free population. Lungkwitz built a farm near the settlement of Fredericksburg, fended off Indians and Confederate partisans, and augmented his income by selling lithographs or practicing the new art of pho-

tography. Above all, he painted Texas scenes in the German Romantic style, recording a transcendental vision of the land in which he buried his loved ones and the life he actually lived (unlike later "cowboy" artists such as Frederic Remington, who often were tourists). The most accomplished Texas artist of the 19th century, Lungkwitz—joined by fellow Germans such as portrait painter Carl Von Iwonski and sculptor Elisabet Ney—bravely led the advance of culture into the frontier. ❧

Below: Mount Bonnell, Austin by **Hermann Lungkwitz, 1875.** *Opposite: Crockett Street Looking West, San Antonio Bexar by* **Hermann Lungkwitz, 1857.** *Both, the Witte Museum, San Antonio*

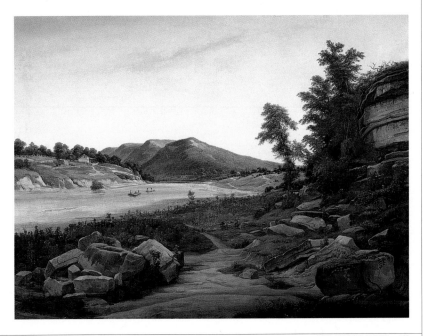

Big Bend Fantasy by Earl Staley, 1992. In Staley's complex postmodern mythology, the Big Bend landscape is inhabited by magical, shamanic forces. *Moody Gallery, Houston*

The historic exodus of talented young Texans like Robert Rauschenberg—who fled his hometown, Port Arthur, in 1945—has been dramatically reversed in recent years, as top art school graduates flock to Houston's thriving art scene to begin their careers. But the new generation of stay-at-home Texas artists, no longer compelled to make the pilgrimage to New York, has had the greatest impact, creating a powerful and distinctive new voice in American art.

Many of Texas's most important contemporary artists were postmodernists years before postmodernism became cool; instead of merely appropriating images with an eye to art-market fashion, they've derived a meaningful symbolic language from the state's rich mix of cultures. Earl Staley is perhaps Texas art's most accomplished and protean storyteller; working with a complex amalgam of Greek, North American Indian,

Mexican, and biblical myths, he relates elegant fables in an expressionistic style that makes all the more convincing his portrayal of miraculous events. Vernon Fisher, a Fort Worth native who rivals Staley as an influence on other Texas artists, often combines banal text, roadside-eye images of West Texas landscapes, and chalkboard-like diagrams to evoke a universe governed by the laws of chaos. ◢

Above: The Art Guys, a.k.a. Michael Galbreath and Jack A. Massing, are Houston-based performance and conceptual artists whose antic projects have included working as convenience store clerks and spending a day at a Denny's restaurant. One curator placed them in the tradition of jesters; the *New York Times* called them "part Dada, part David Letterman." This is from a recent piece, *The Suits. Photo Will van Overbeek. Left: Chameleon* by Ibsen Espada, 1997. *McMurtrey Gallery, Houston*

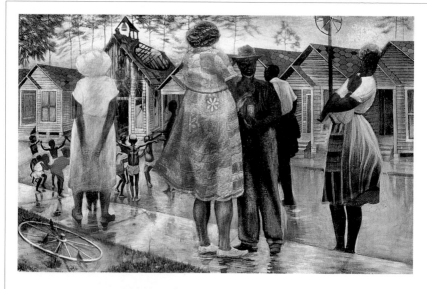

Struck by the scale, boldness, and racial pride of Mexican revolutionary painters such as Rivera and Orozco, John Biggers has created an ambitious series of murals based on his African heritage. James Surls, who grew up in rural East Texas, shapes logs and branches into organic forms, creating a personal nature mythology of Vedic complexity. And Melissa Miller recalls girlhood experiences on her family's central Texas farm in swirling, Romantic animal paintings that often refer to the catastrophes of the Texas climate.

Left: Night Wings by Melissa Miller, 1996. *Gerald Peters Gallery, Dallas. Below: Dancing on the Bridge* by James Surls, 1992. *Gerald Peters Gallery, Dallas. Opposite above: Shotgun, Third Ward #1* by John Biggers, 1966. Biggers's shotgun-house paintings depict the Third Ward and Sunnyside neighborhoods of his adopted Houston. *National Museum of American Art, Washington, D. C./Art Resource, New York. Opposite below: Lynch's Pier* by Ann Stautberg, 1998. Galveston resident Anne Stautberg's hand-tinted photographs evoke the wistful romance and the often stark anomie of the Texas coast. *Barry Whistler Gallery*

This profound sense of place is equally apparent among emerging Texas artists, though often teamed with ironic references to a rapidly changing social landscape. The vast suburbs that are now the fastest-growing frontier get their due in Lee N. Smith's surrealistic recollections of his youth on the fringes of Dallas. Mixed-media artist Celia Alvarez Muñoz appropriates conventions such as *retablos* and *santos* from traditional Mexican art, but combines them with a feminist outlook on biculturalism and women's roles. And Julie Bozzi's meticulously crafted landscapes, only a few inches high, reduce the stereotypical sweep of the Texas horizon to a snapshot perspective.

Museum for Moderns

Texans have a tradition of paying big bucks to import great architects. Sometimes they even get great architecture, as with Louis Kahn's Kimbell Art Museum in Fort Worth, a masterpiece of pared-down, classicized modernism. The Kimbell's barrel-vaulted galleries, flooded with natural light, showcase a small but luminous collection of masters new and old. And the building itself has become a sacred site for architecture buffs.

Homage à l'Orange

Houston mail carrier Jeff McKissack labored from 1956 until his death in 1980 to create a backyard monument to the orange. A Rube Goldbergesque amusement park constructed from salvaged building parts, tractor-seat chairs, and metal birds, festooned with slogans such as "Oranges for energy," the monument McKissack aptly called the Orange Show is now Texas's premier folk-art attraction.

Texas Preacher Tops Wright Brothers

According to the official Texas Historical Marker at the site, a Pittsburg, Texas, Baptist minister built a paddle-powered flying machine based on the description of the flying "wheels" in the biblical book of Ezekiel—and briefly flew it in 1902, a year before the Wright brothers got airborne. A full-sized replica is displayed at the Northeast Texas Rural Heritage Center in Pittsburgh.

Old Jail, New Art

Stunning art collections cached in the middle of nowhere are a Texas tradition. The Old Jail Art Center, housed in the former Shackleford County Jail (built 1878) in the former cattle-trail stop of Albany (pop. 2,438), contains a superb collection of ancient Chinese ceramic tomb sculptures as well as modern works by Picasso, Braque, Modigliani, and even Warhol. When the rusticated limestone structure actually was a jail,

its collection of celebrity felons included John Selman, noted for shooting John Wesley Hardin.

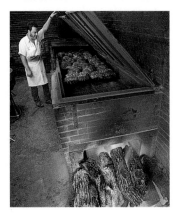

Barbecue as God Intended

Lockhart's century-old Kreuz (pronounced "krites") Market is Texans' consensus choice for the state's best barbecue. Patrons from around the state queue up for beef brisket served on butcher paper with a plastic knife—no plates, forks, potato salad, beans, or sauce. You'd prefer the extras? Kansas City's only about 700 miles due north.

"Houston, We Have a Rocket"

The first word spoken from another celestial body was "Houston." The 340-foot-tall Saturn V rocket that got us there, displayed supine at NASA's Clear Lake City campus, is as awe-inspiring as anything made by humans.

Great People

A selective listing of native Texans, focusing on the arts.

Willie Nelson (b. 1933), the Texas Sinatra; hails from Abbott

Gene Autry (1907–1998), born and raised in Tioga; the "Singing Cowboy" and Hollywood's top box-office draw in the 1930s

Gail "Gil" Borden (1801–1874), dairyman who received patent for condensed milk in 1856; founded Borden Company

John Henry Faulk (1913–1990), homespun humorist and radio raconteur; tireless advocate for civil rights and civil liberties.

Buddy Holly (1936–1959), Lubbock rocker; without his Crickets, there would have been no Beatles

Tommy Lee Jones (b. 1946), Academy Award–winning actor; born in San Saba, educated in Dallas

Janis Joplin (1943–1970), Port Arthur native—and outcast—who became the raw musical voice of an alienated generation

Scott Joplin (1868–1917), ragtime composer; won 1976 Pulitzer Prize for his opera, *Treemonisha*

Larry McMurtry (b. 1936), Pulitzer Prize–winning novelist (*Lonesome Dove, The Last Picture Show*) has written more perceptively about Texas than anyone, ever

Mary Martin (1913–1990), diminutive Broadway titan; born in Weatherford, as was her son, Larry Hagman, J. R. Ewing in TV's *Dallas*

Adah Isaacs Menken (1835–1868), notorious stage actress and poet; performed Shakespeare in Texas towns

Audie Murphy (1924–1971), WWII's most decorated soldier; made 45 movies and wrote a best-seller about his exploits

Carrie Marcus Neiman (1883–1953), founder, with her husband, Al Neiman, and brother, Herbert Marcus, of Neiman Marcus, in 1907

Elisabet Ney (1833–1907), pioneering sculptress; trained in Berlin, arrived in Texas in 1872

Selena Quintanilla Perez (1971–1995), breakout *tejano* singer; martyred by a fanatical fan

Katherine Anne Porter (1890–1980), author of *Pale Horse, Pale Rider* and *Ship of Fools;* some consider her Texas's greatest writer

Robert Rauschenberg (b. 1925), born and raised in Port Arthur; innovative and influential artist of post-WWII era

Aaron Spelling (b. 1928), Dallas native and producer who put the sizzle in prime-time TV

Tommy Tune (b. 1939), from Wichita Falls; won Tony Awards as a dancer, actor, choreographer, and director

Robert Wilson (b. 1943), giant of avant-garde theater (*The Life and Times of Joseph Stalin, Einstein on the Beach*); born and raised in Waco

. . . and Great Places

Some interesting derivations of Texas place names.

Alpine West Texas town just high enough, at 4,400 feet, to aspire to greater heights.

Bug Tussle Town so tiny, the story goes, that the only diversion was watching bugs fight.

Crush Double entendre inspired by a railroad agent named William G. Crush, who arranged for two speeding trains to collide head-on here in 1896.

Dime Box Town named after the community mail box and the fee paid passing wagons to carry each piece of mail.

El Paso Spanish explorers called the location of Texas's fourth largest city *El Paso del Norte* —the pass of the North.

Floydada Named after Alamo defender Dolphin Floyd and a local rancher's mother, Ada.

Iraan Not the middle-eastern country; named for local ranchers Ira and Ann Yates.

Langtry Legend says the town was named by Judge Roy Bean in honor of actress Lillie Langtry, but the pertinent Langtry was actually an English civil engineer.

La Reunion French utopians hoped for *la reunion* in Texas, but their colony near Dallas foundered in the 1850s.

Llano Estacado Spanish explorers called the perfectly flat escarpment that extends over most of the Panhandle the "staked plains." Nobody knows why.

Lonesome Dove Townsfolk trying to decide on a name for their North Texas community were impressed by a lone dove cooing in yonder oak tree.

Marfa Named by a Dostoyevsky reader for a character in *The Brothers Karamazov*.

New Braunfels Prince Carl de Solms-Braunfels named this hill country immigrant colony after his estate in Germany.

Odessa Early settlers thought the West Texas countryside looked like the steppes of Russia.

Quanah Captured by Comanches, Cynthia Ann Parker became mother of famed chief Quanah Parker. The Montague County seat was named in his honor.

Snook Postmaster J. S. Snook helped this town get a post office.

Terlingua "Three tongues" or "three tribes" may have been the source for the Tex-Mex name of this former mining town, now site of a notorious annual chili cook-off.

XIT Ranch Famous cattle brand derived from X (ten) I (in) T (Texas), referring to the ten counties over which the enormous ranch sprawled.

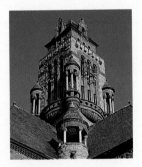

Waxahachie Tonkawa Indian name for dried cow excrement is generously translated by locals as "cow creek."

TEXAS BY THE SEASONS
A Perennial Calendar of Events and Festivals

Here is a selective listing of events that take place each year in the months noted; we suggest calling ahead to local chambers of commerce for dates and details.

January

Dallas
Cotton Bowl
Parade precedes the annual football classic.

Fort Worth
Southwestern Exposition and Livestock Show and Rodeo
One of the largest livestock expos in the nation.

February

Brownsville
Charro Days
Four-day Mexican rodeo fiesta.

Galveston
Mardi Gras
Parades, floats, masked balls; a lively but more PG version than the New Orleans event.

Laredo
George Washington's Birthday
Parades, beauty contest, *tejano* music, Mexican food.

Odessa
Shakespeare Festival
The state's oldest, in a replica of London's Globe Theatre.

March

Alpine
Texas Cowboy Poetry Gathering
Cowboy poets gather at Sul Ross State University.

Austin
South by Southwest Music and Media Conference
Hundreds of regional music acts and industry scouts show up for this annual pop music expo.

Houston
Azalea Trail
Tour some of Houston's most elegant homes and gardens.

FotoFest
Biennial international fair with dozens of exhibitions; a must for photography professionals.

Sweetwater
Jaycees Rattlesnake Roundup
Ritual slaughter, but venom is used for medicinal purposes and the meat is eaten.

April

Houston
Art Car Weekend
The nation's largest gathering of exuberantly decorated automobiles and "traveling sculptures."

San Antonio
Fiesta
Massive, distinctly Texan blowout; 10 days of parades, balls, rodeos, and local music.

Waco
Brazos River Festival
Tours of restored historic homes along the Brazos River.

May

Athens
Old Fiddlers' Reunion
Fiddlers from all over gather in the courthouse square.

Ennis
National Polka Festival
The city's large Czech population celebrates with costumes, street dancing, parades, and polka bands.

Fort Worth
Van Cliburn International Piano Competition
Held every four years; 35 talented young pianists vie for prize that can make a career.

Kerrville
Kerrville Folk Festival
Outdoor concert featuring national and local blues, folk, and country music performers.

Statewide
Cinco de Mayo
Festivals in many Texas cities celebrate Mexican defeat of French invasion force in 1860s.

June

Luling
Watermelon Thump
Three-day festival features melon judging and seed-spitting world championship.

Round Top
International Festival-Institute
Acclaimed series of orchestral and chamber music concerts.

Waxahachie
Gingerbread Trail Tour of Homes
Preserved Victorian homes and town square open up for this popular nostalgia tour.

Around the State
Juneteenth
African Americans celebrate June 19, 1865, when Texas slaves were pronounced free.

July

Clute
Great Texas Mosquito Festival
Ms. Quito beauty contest, mosquito swatter decorating and mosquito-calling contests.

Houston
Introductions
Artwalk opens series of exhibitions featuring talented but unknown artists.

Luckenbach
Willie Nelson's Fourth of July Picnic
Willie and musical friends perform at this annual concert.

Pecos
West of the Pecos Rodeo
Billed as the world's first professional rodeo; features top pros in traditional events.

August

Castroville
St. Louis Day
Alsatian heritage event with arts and crafts, food, music and dance.

Dalhart
XIT Rodeo and Reunion
Features the world's biggest free barbecue—six tons of beef cooked in pit 75 feet long.

San Antonio
Texas Folklife Festival
Features the food, dance, arts, and crafts of Texas's many ethnic and cultural groups.

September

Corpus Christi
Bayfest
Waterfront festival with boat races, parade, entertainment.

Grand Prairie
National Championship Pow-Wow
Major gathering of Native Americans features dance competitions, food, crafts.

Lufkin
Texas Forest Festival
Carnival, concert, barbecue, hushpuppy Olympics, lumberjack shows.

October

Dallas
State Fair of Texas
Nation's largest state fair has new cars, traditional livestock shows, and midway, all set among 1930s Deco-style buildings.

Flatonia
Czhilispiel
Czechs take on chili at this cook-off and festival.

Fredericksburg
Oktoberfest
Largest and oldest of hill country Oktoberfest celebrations.

Tyler
Texas Rose Festival
Rose-decorated floats, and coronation of the Rose Queen at the state's biggest floral festival.

November

New Braunfels
Wurstfest
Celebrate German sausage in the quintessential hill country German town.

Terlingua
World Championship Chili Cook-off
Increasingly rowdy, now split into two rival events, yet remains a Texas institution.

December

Galveston
Dickens on the Strand
Costumed Dickensian characters re-create Victorian London.

San Antonio
Las Posadas
Traditional Mexican candlelight procession along the beautiful Paseo del Rio (River Walk).

WHERE TO GO
Museums, Attractions, Gardens, and Other Arts Resources
Call for seasons and hours when open.

Museums

THE AMON CARTER MUSEUM
3501 Camp Bowie Blvd., Ft. Worth, 817-738-1933
Outstanding collection of 19th- and early 20th-century American painting and photography in a Philip Johnson–designed building.

THE ART MUSEUM OF SOUTHEAST TEXAS
500 Main St., Beaumont, 409-832-3432
Good representation of regional folk art.

THE CHINATI FOUNDATION
P.O. Box 1135, Marfa, 915-729-4362
Scores of minimalist concrete and aluminum sculptures by the late Donald Judd at the former Fort D. A. Russell; another building contains his pal John Chamberlain's crushed-auto sculptures.

CONTEMPORARY ARTS MUSEUM
5216 Montrose Blvd., Houston, 713-284-8250
No permanent collection, but this sheet-metal trapezoid showcases cutting-edge exhibits focusing on international and Texas artists.

COWBOY ARTISTS OF AMERICA MUSEUM
1550 Bandera Hwy., Kerrville, 830-896-2553
Distinctive, hacienda-style building designed by O'Neil Ford houses rotating exhibits of Western historical realism by the 25 member artists.

DALLAS MUSEUM OF ART
1717 N. Harwood, Dallas, 214-222-1200
Wide-ranging collection housed in a vast Edward Larrabee Barnes–designed building; one of the world's finest collections of Pre-Columbian artifacts.

DR. PEPPER MUSEUM
300 S. 5th. St., Waco, 254-757-1024
Housed in original 1906 Dr. Pepper bottling plant; exhibits detail history of Texas's favorite soft drink.

INSTITUTE OF TEXAN CULTURES
801 S. Bowie, San Antonio, 210-458-2300
Permanent and special exhibits tell the story of Texas's cultural diversity.

KIMBELL ART MUSEUM
3333 Camp Bowie Blvd., Fort Worth, 817-332-8451
Louis Kahn's luminous building is a masterpiece, as is just about everything this prodigiously wealthy little museum displays. A unique experience in viewing art.

LYNDON BAINES JOHNSON LIBRARY AND MUSEUM
2313 Red River, Austin, 512-916-5137
Includes a seven-eighths scale replica of the Oval Office and a life-sized, animated figure of LBJ.

MENIL COLLECTION
1515 Sul Ross, Houston, 713-525-9400
Innovative Renzo Piano–designed building houses the Menil family's world-renowned collection, spanning prehistory to Pop.

MUSEUM OF FINE ARTS, HOUSTON
1001 Bissonnet, Houston, 713-639-7300
A major expansion opening early in 2000 will make this museum the nation's sixth largest. Especially strong in European and American Impressionists.

NATIONAL RANCHING HERITAGE CENTER
4th St. and Indiana Ave., Lubbock, 806-742-2490
Thirty authentic ranch buildings, including dugouts, bunkhouses, and ranch homes.

OLD CITY PARK
1717 Gano, Dallas, 214-421 4151
Thirty-six restored homes and businesses dating
from 1840 to 1910, arranged in a village-like setting.

PANHANDLE-PLAINS HISTORICAL MUSEUM
2401 4th Ave., Canyon, 806-656-2244
Enormous storehouse of artifacts and documents
tracing the history of the Texas Panhandle, as well
as an important collection of Texas art.

SAN ANTONIO MUSEUM OF ART
200 W. Jones Ave., San Antonio, 210-978-8100
Housed in the imaginatively restored Lone Star
Brewery; fine collection of Greco-Roman antiquities
and Latin American art.

THE SIXTH FLOOR MUSEUM
411 Elm St., Dallas, 214-747-6660
Located in the former Texas School Book Depository,
this dignified examination of JFK's life and death is
one of Texas's top tourist attractions.

Attractions

THE ALAMO
300 Alamo Plaza, San Antonio, 210-225-1391
Heavily restored icon is visited by more tourists than
any other Texas site.

ARANSAS NATIONAL WILDLIFE REFUGE
P.O. Box 100, Austwell, 512-286-3559
Birdwatcher's paradise on the Gulf Coast, with rare
whooping cranes resident November–March.

BIG BEND NATIONAL PARK
Big Bend National Park, 915-477-2251
Rapids, rafting, spectacular mountain and desert
vistas—and relatively sparse crowds.

BIG THICKET NATIONAL PRESERVE
Big Thicket National Preserve, 409-246-2337
Eight major "ecotones" collide to create a biodiversity
wonderland; 1,000 species of wildflowers.

FORT DAVIS NATIONAL HISTORIC SITE
P.O. Box 1456, Fort Davis, 915-426-3225
Considered the best-preserved frontier fort in the
Southwest, this cavalry outpost protected travelers
and merchants along the San Antonio–El Paso Road.

GUADALUPE MOUNTAINS NATIONAL PARK
HC 60, Box 400, Salt Flat, 915-828-3251
Perhaps the most pristine wilderness of any national
park in the contiguous 48 states. Attractions include
Guadalupe Peak, the highest point in Texas (8,749 ft.).

HUECO TANKS STATE HISTORICAL PARK
6900 Hueco Tanks Rd. No. 1, El Paso, 915-857-1135
Five thousand Native American pictographs (includ-
ing the earliest known "kachina mask" paintings)
adorn massive, strangely pocked granite uprisings.

KING RANCH
P.O. Box 1090, Kleberg, 512-592-8055
The world's largest privately held ranch offers daily
guided tours.

MISSION SAN JOSE
2202 Roosevelt Ave., San Antonio, 210-932-1001
Exquisitely carved stone facade; one of the finest U.S.
examples of Spanish Renaissance architecture.

NASA SPACE CENTER HOUSTON
1601 NASA Road One, Houston, 281-244-2105
The Disney-designed visitor center for NASA's
Johnson Space Center offers imaginative interactive
exhibits as well as tours of Mission Control.

PALO DURO CANYON STATE PARK
RR 2, Box 285, Canyon, 806-488-2227
Rugged, 120-mile-long, 1,200-foot-deep canyon offers
some of Texas's most spectacular Wild West scenery.

SAN JACINTO BATTLEGROUND STATE
HISTORICAL PARK
3523 Hwy. 134, LaPorte, 281-479-2431
Site of Sam Houston's 1836 victory is marked by a 570-
foot-tall obelisk. The battleship *Texas*, a naval muse-
um, is anchored in the adjacent Ship Channel.

Homes and Gardens

BAYOU BEND COLLECTION AND GARDENS
1 Westcott St., Houston, 713-639-7750
1927 "Latin colonial" mansion contains Ima Hogg's
superb American furniture and art; surrounded by
14 acres of formal gardens.

BISHOP'S PALACE
1402 Broadway, Galveston, 409-762-2475
Designed by Nicholas Clayton, fully restored and fur-
nished in period (Victorian) style, this is considered
the finest historic home in a city chock full of them.

DALLAS ARBORETUM AND BOTANICAL GARDENS
8525 Garland Rd., Dallas, 214-327-8263
Some 66 acres of gardens on the grounds of the
Spanish Colonial Revival DeGolyer Mansion by
Bel-Air Hotel designer Burton Schutt.

FREEMAN PLANTATION
Rte. 49, Jefferson, 903-665-2320
Fully furnished with antebellum antiques, this 1850
Greek Revival house was built by slaves for a cotton
and sugarcane grower.

GOVERNOR'S MANSION
1010 Colorado St., Austin, 512-463-5516
Abner Cook's elegantly austere Greek Revival build-
ing has stood virtually unchanged since 1856.

LINDHEIMER HOME
491 Comal, New Braunfels, 830-625-8766
German botanist's house built (1852) in wood-and-
cedar *fachwerk* style used by German immigrants.

MAGOFFIN HOMESTEAD
1120 Magoffin Ave., El Paso, 915-533-5147
Built in 1875, this adobe mansion is a rare surviving
example of the Territorial Style.

SPANISH GOVERNOR'S PALACE
105 Military Plaza, San Antonio, 210-224-0601
Built in 1749 and restored in 1929; many Spanish
colonial antiques.

TYLER MUNICIPAL ROSE GARDEN AND MUSEUM
420 S. Rose Park Dr., Tyler, 903-531-1212
Showpiece of the "Rose Capital of America"; 14 acres
showcasing 400 varieties, along with a visitor center.

Other Resources

TEXAS DEPARTMENT OF TRANSPORTATION
125 E. 11th St., Austin, 512-463-8585
Wide range of tourism and travel information.

TEXAS HISTORICAL COMMISSION
1511 Colorado St., Austin, 512-463-6100
Information and publications on historic sites.

TEXAS PARKS AND WILDLIFE
4200 Smith School Rd., Austin, 800-792-1112
Official information on state parks and outdoor
activities.

CREDITS

The authors have made every effort to reach copyright holders of text and owners of illustrations, and wish to thank those individuals and institutions that permitted the reprinting of text or the reproduction of works in their collections. Credits not listed in the captions are provided below. References are to page numbers; the designations a, b, and c indicate position of illustrations on pages.

Text

Addison-Wesley Publishing Co.: *Friday Night Lights: A Town, a Team, and a Dream* by H. G. Bissinger. Copyright © 1990 by H. G. Bissinger.

Gulf Publishing Co.: *Cowboys and Cadillacs: How Hollywood Looks at Texas* by Don Graham (Austin: Texas Monthly Press, 1983). Copyright © 1983 by Don Graham.

Lynn Loughmiller: *Big Thicket Legacy*, compiled and edited by Campbell and Lynn Loughmiller. Copyright © 1977 by Campbell and Lynn Loughmiller. Reprinted by permission.

Scott, Foresman & Co.: *The Great Plains* by Walter Prescott Webb. Copyright © 1931 by Ginn & Co. Reprinted by permission.

Simon & Schuster, Inc.: *Lonesome Dove* by Larry McMurtry. Copyright © 1985 by Larry McMurtry. Reprinted with permission.

University of Oklahoma Press: *The Texas Republic: A Social and Economic History* by William Ransom Hogan. Copyright © 1946 by William Ransom Hogan. Used with permission.

University of Texas Press: *Rip Ford's Texas* by John Salmon Ford, edited by Stephen B. Oates. Copyright © 1963, 1987 by University of Texas Press. *A Vaquero of the Brush Country* by John D. Young and J. Frank Dobie. Copyright © 1929, 1957, 1985 by University of Texas Press. Both, reprinted by permission.

Illustrations

ARMADILLO CHRISTMAS BAZAAR, AUSTIN: **76a**; BARRY WHISTLER GALLERY: *Lynch's Pier* by Ann Stautberg, 1998. Oil on black & white photo. 56 x 50"; BERGGRUEN GALLERY, SAN FRANCISCO: **21a** *Caddo Lake* by David Bates, 1987. Oil on canvas. 84 x 64"; **71** *Flagship Pier* by David Bates, 1992. Acrylic and oil on canvas. 20 x 24"; BEXAR COUNTY AND

THE WITTE MUSEUM, SAN ANTONIO: **33** *West Side Main Plaza* by William G. M. Samuel, 1849. Oil on canvas mounted on panel. 22 x 36"; CAROLYN BROWN: **43; 48; 70a; 70b; 86b** The Orange Show; **89** Waxahachie; CENTER FOR AMERICAN HISTORY, UNIVERSITY OF TEXAS: **74b; 78a** Walter Prescott Webb; **79a**; THE CHINATI FOUNDATION, MARFA: **53a** 100 untitled works in mill aluminum by Donald Judd, 1982–86. Permanent installation in two former artillery sheds at the Chinati Foundation, Marfa. Photo Todd Eberle; CORBIS: **15a; 15c; 87c** Saturn V rocket. Photo Roger Ressmeyer; GEORGE CORSILLO: **78b** Jacket design for *Lonesome Dove*; DALLAS HISTORICAL SOCIETY: **41a** *East Texas of Today, After the Discovery of Oil* by Olin Travis, 1936. Oil on canvas. 16¼ x 40"; DALLAS MUSEUM OF ART: **18** *Squaw Creek Valley* by Florence E. McClung, 1937. Oil on canvas. 24 x 30". Gift of Florence E. McClung; **36** *House Mountain on the Llano* by Frank Reaugh, c. 1900. Oil on canvas. 13½ x 29½"; DALLAS MUSEUM OF ART/THE ESTATE OF OTIS DOZIER: **35a** *Cotton Boll* by Otis Dozier, 1936. Oil on masonite. 20 x 16". Gift of Eleanor and Tom May; GERALD PETERS GALLERY, DALLAS: **85a** *Night Wings* by Melissa Miller, 1996. Watercolor on paper. 41½ x 29½"; **85b** *Dancing on the Bridge* by James Surls, 1992. Red oak, white oak. 11 x 78½ x 43"; **45b** *Sacred Heart Church #2* by David Bates, 1998. Painted wood and metal. 21 x 23½ x 21¾"; IMAGE BANK: **10; 16** Oil Wells at Spindletop, Texas, 1900; JACK S. BLANTON MUSEUM OF ART, UNIVERSITY OF TEXAS: **40** *Oil Field Girls* by Jerry Bywaters, 1940. Oil on board. 30 x 25". Purchased through the generosity of Mari and James A. Michener, 1984. Photo George Holmes; COLLECTION MRS. PATRICIA JOHN KEIGHTLEY: **44** *Easter* by Grace Spaulding, 1933. Oil on canvas. 84 x 68"; LUCCHESE, INC.: **15b** Boots; LYNDON BAINES JOHNSON LIBRARY AND MUSEUM: **56** *Lyndon B. Johnson* by Steve Yuryani, 1971. Fiberglass and wire. 28" h.; WALTER NOLD MATHIS, SAN ANTONIO: **12c** Watch case. Gold. 2 x 3¼". Photo the Witte Museum; ROBERT McCLAIN & CO., HOUSTON: **53b** *Houston Police Officers Memorial* by Jesús Bautista Moroles, 1992. Texas granite, earth, grass, and water. 23 x 120 x 120'; McMURTREY GALLERY, HOUSTON: **83b** *Chameleon* by Ibsen Espada, 1997. Tempera and oil on rice paper and canvas. 72 x 56"; WYATT McSPADDEN: **87a** Old Jail Art Center; **87b** Kreuz Market; THE MENIL COLLECTION, HOUSTON: **46a** *Flowers* by Jim Love, 1965. Cast iron and cast steel. 27½ x

19". Photo Hickey-Robertson, Houston; **46b** *Untitled (Scatole Personali)* by Robert Rauschenberg, c. 1952. Lidded painted wood box with printed reproductions, paper and fabric, containing bird. Photo G. Hixson; WENDELL MINOR: **1** *The Evening Star* (detail), 1992. Watercolor on cold press paper. 9 x 12"; MODERN ART MUSEUM OF FORT WORTH: **20b** *Edge of the Piney Woods* by Julie Bozzi, 1987–88. Oil on paper. 22 x 30". The Benjamin J. Tillar Memorial Trust; MOODY GALLERY, HOUSTON: **24** *S.W.I.S. Rim, Big Bend #1* by Earl Staley, 1987–91. Acrylic on canvas. 24 x 48"; **82** *Big Bend Fantasy* by Earl Staley, 1992. Acrylic on canvas. 62¾ x 47"; NATIONAL GEOGRAPHIC SOCIETY IMAGE COLLECTION: **12a** Texas flag. Illustration by Marilyn Dye Smith; **12b** Mockingbird and bluebonnet. Illustration by Robert E. Hynes; NATIONAL MUSEUM OF AMERICAN ART/ART RESOURCE: **27a** *Comanche village* by George Catlin, 1834. Oil on fabric, mounted on aluminum. 20 x 27¼"; **84a** *Shotgun, Third Ward #1* by John Biggers, 1966. Oil on canvas. 30 x 48"; THE NOBLE FOUNDATION, ARDMORE, OKLA.: **58a** *Nestled* by Tom Ryan, 1987. Charcoal on paper. 28 x 38". Photo courtesy the artist; OGDEN MUSEUM OF SOUTHERN ART: **31** *Battle of the Alamo* by Hugo David Pohl, c. 1936. Oil on canvas. 44 x 73"; PANHANDLE-PLAINS HISTORICAL MUSEUM: **27b** *White Eagle's Shield* (Comanche), c. 1870. Feathers, rawhide, cloth; **28a** *Coronado's Coming* by Ben Carlton Mead, 1934. Oil on canvas. 78 x 144"; PRIVATE COLLECTION: **17;** THE ROGER HOUSTON OGDEN COLLECTION, NEW ORLEANS: *Bluebonnets and Huisache at Twilight* by Julian Onderdonk, 1920–21. Oil on canvas. 30 x 40"; SAN ANTONIO ART LEAGUE MUSEUM: **2** *The Horse Wrangler* by W. Herbert Dunton, 1928. Oil on canvas. 25 x 20"; **25a** *Cactus Flowers* by José Arpa, 1928. Oil on canvas. 30 x 40"; **34** *Picking Cotton* by José Arpa, 1929. Oil on canvas. 30 x 40"; **38a** *Old Texas* by W. Herbert Dunton, 1929. Oil on canvas. 28 x 39"; **65** Virgin of Guadalupe bedspread, c. 1930, South Texas. Crocheted cotton. 96 x 72"; 6666 RANCH: **39** *The Long Day* by Tom Ryan, 1994. Oil on canvas. 32 x 32". Photo courtesy the artist; STARK MUSEUM OF ART, ORANGE: **19b** *Red Texan Wolf* by John James Audubon, 1845. Hand-colored lithograph. 21½ x 27½"; COLLECTION MR. CHARLES STEVENSON, TULSA: **5** *Spindletop Runs Wild* by Alexandre Hogue, 1940. Oil on canvas. 40 x 30". Photo Art Museum of Southeast Texas; COLLECTION MR. AND MRS. WILLIAM J. TERRELL, SR.: **35b** *Terrell Cotton Gin* by

Ethel Spears, c. 1940s. Watercolor on paper. 22 x 31½"; TEXAS DEPT. OF TRANSPORTATION: **20a** Photo Richard Reynolds; **47; 49a; 52b; 57a; 60a; 63; 86a** Kimbell Art Museum. Photo Jay Griffis Smith; TEXAS STATE LIBRARY AND ARCHIVES, AUSTIN: **29** *Champ d'Aisle;* **30** *The San Jacinto Battle Flag;* **54** Stephen F. Austin. Oil on canvas. 40 x 35"; **37a** Charles Goodnight; WILL VAN OVERBEEK: **13b; 25b; 28b; 50; 51; 52; 67; 69; 76b; 77b; 83a; 88** Willie Nelson; SABIN WARRICK/PITTSBURG HOT LINK PACKERS, INC.: **86c** Ezekiel airship; WEBB GALLERY, WAXAHACHIE: **11** Face jug by Carl Block, 1998. 20 x 16 x 14"; **64b** *Jimbo Man* by Reverend J. L. Hunter, 1992. Wood, paint, mixed media. 63 x 31 x 16"; THE WITTE MUSEUM, SAN ANTONIO: **19a** *Indian Paint Brush* by Mary Motz Wills, c. 1913–36. Watercolor on paper. 11½ x 6¾". Purchase from Mary Motz Wills with Witte Picture Fund; **26** *Comanche Chief* by Theodore Gentilz, c. 1890s. Oil on canvas. 12 x 9"; **32** *Portrait of Sam Houston* by William G. M. Samuel, c. after 1856. Oil on canvas. 60¼ x 41"; **64a** *Aero Babymyn* by C. A. A. Dellschau, c. after 1908. Watercolor and ink on heavy paper. 12½ x 19¼"; **66b** *Chili Stand* by Clara Caffrey Pancoast, c. 1940s. Oil on canvas on board. 25 x 31½"; **80** *Crockett Street Looking West* by Hermann Lungkwitz, 1857. Oil on canvas. 13 x 20". Purchase; **81** *Mount Bonnell, Austin* by Hermann Lungkwitz, 1875. Oil on canvas. 26 x 36". Gift; YANAGUANA SOCIETY COLLECTION, DAUGHTERS OF THE REPUBLIC OF TEXAS LIBRARY: **9** *El convite para el baile* by Theodore Gentilz, c. 1890s. Oil on canvas. 9 x 12". Gift in memory of Frederick C. Chabot, 1947

Acknowledgements

Walking Stick Press wishes to thank our project staff: Miriam Lewis, Joanna Lynch, Thérèse Martin, Laurie Donaldson, Inga Lewin, Tena Scalph, and Kristi Hein.

For other assistance with *Texas,* we are especially grateful to: Lindsay Kefauver, Jan Hughes, Jeannie Taylor, Timothy Taylor, Dennis Hearne, Rebecca Huffstutler of the Witte Museum, Rachel Mauldin of the San Antonio Museum of Art, John Anderson of the Texas State Library and Archives, Anne Çook and Mike Murphy of the Texas Dept. of Transportation, and Shelly Rutledge of Will van Overbeek Photography.